No Green Berries or Leaves

Praise for Paul Stankard and
No Green Berries or Leaves

Paul is the greatest and most interesting paperweight maker that has ever lived. His book is a fascinating achievement.
— Dale Chihuly, Chihuly Studio, Seattle, WA

Paul Stankard's charm, directness, and modesty come through in every sentence of this memoir.
— David Revere McFadden, Chief Curator,
Museum of Arts & Design, New York City, NY

Paul Stankard has long been acknowledged as the master flameworker in America; who knew he could write, too? The spiritual core at the center of his life and his art shines through on every page.
— Ulysses Grant Dietz, Curator of Decorative Arts, Curator of the
Ballantine House, The Newark Museum, Newark, NJ

Paul Stankard tells a spirited and personal story of achievement with the grace and humility of one who treasures life and values learning. Stankard's passionate journey in glass and his life as an artist and educator is beautifully told.
— Jean W. McLaughlin, Director, Penland School
of Crafts, Spruce Pine, NC

This ingenuous account of Paul's personal Odyssey is a privileged, intimate look at the ongoing creative process of a modern master.
— Richard Rosenfeld, Owner/Director,
Rosenfeld Gallery, Philadelphia, PA

As one of the eminent glass artists of the 20th and 21st centuries, Paul's is a story that inspires, educates, and encourages us all.
— Dr. Anne Steele, President, Muskingum College,
New Concord, OH

This book is a wonderful account for all to understand the process of becoming a creative being.
— Shane Fero, Studio Glass Artist;
President, The Glass Art Society

No Green Berries or Leaves

The Creative Journey
of an Artist in Glass

by

Paul J. Stankard

with a foreword by Virginia Eichhorn

The McDonald & Woodward Publishing Company
Blacksburg, Virginia

The McDonald & Woodward Publishing Company
Blacksburg, Virginia, and Granville, Ohio

No Green Berries or Leaves
The Creative Journey of an Artist in Glass

© 2007 by Paul J. Stankard

First printing: September 2007

15 14 13 12 11 10 09 08 07 10 9 8 7 6 5 4 3 2 1

Library of Congress Cataloging-in-Publication Data

Stankard, Paul, 1943-
 No green berries or leaves : the creative journey of an artist in glass
 by Paul J. Stankard.
 p. cm.
 Includes index.
 ISBN-13: 978-0-939923-55-7 (softcover : alk. paper)
 ISBN-13: 978-0-939923-69-4 (hardcover : alk. paper)
 1. Stankard, Paul, 1943- 2. Glass artists—United States—
Biography. 3. Artists with disabilities—United States—Biography.
4. Glass art—United States—History—20th century. I. Title.
 NK5198.S677A2 2004
 748.092—dc22

 2007027639

Contents

Dedication

This book is dedicated to my wife Patricia,
our children, and our grandchildren.

Foreword

Virginia Eichhorn

Curator, Canadian Clay & Glass Museum
Waterloo, Ontario, Canada

Is it possible that in one magical moment in time, my destiny was sealed for life?

— Paul Stankard

That moment in time as described early in acclaimed artist Paul Stankard's autobiography occurred when he was a child. Attending the Firemen's Bonfire and Carnival in Attleboro Falls, Massachusetts, on the Fourth of July, he was transfixed by a side table offering prizes of red plastic roses that were placed in glass bowls filled with water. With the fixed determination that has become a trademark of his approach to his art making, he set out to win one of those prizes for his mother. And, with the help of his beloved father, he did so. This humble item was seen as an

object of great beauty by him. His adored mother recognized it as the genuine gift of love that it was, and she kept it on her dresser for the remainder of her life. It was when she passed away, forty-three years later, that Stankard re-encountered it and thought back to that long-ago night. As the memory came back to him — of the bonfire and the rose in glass — he wondered if that was the night, with its combination of fire, glass, and nature, that the seeds were planted that would eventually lead him to a career in glass and art.

Stankard's autobiography is much more than the story of one man's life. It is the story of many triumphs that come about through tireless commitment to hard work and perfecting his craft and his art. For those who think that artists attain fame and success through rebellion and flaunting of traditions and conventions, this story will be eye opening. For those who assume that artists all live somewhat disreputable Bohemian personal lives, it will be a phenomenal awakening. The only other thing to which Stankard has been as devoted and committed to as his art making is his wonderful and equally committed wife, Pat, and their children and grandchildren. To those who have been labeled in diminishing or pejorative ways, who have been told that they can't learn or aren't good enough, who have doubted themselves and what they can accomplish, Stankard's story will be nothing short of inspiring. And for anyone interested in art, particularly of the art scene and movements in the studio glass world in the United States, the story will be a delight, being not only incredibly informative but a lovely read in which one can easily hear the echoes of Irish storytellers from generations past in the gentle cadence of Stankard's writing style.

Much has happened in this life well-lived. Stankard's history, development, and growth as an artist, an artist who is recognized internationally as the most important and accomplished paperweight artist in the world, parallels the rise of the studio glass movement and the coming of age of glass as a respected medium for fine art. In order to reach his present stature, however, there were many struggles for Stankard to overcome.

In the 1950s and 60s no one really understood or heard much about dyslexia. Children who had trouble reading or writing, doing mathematics, or dealing with any of the myriad other ways that this learning disability manifests itself were considered either lazy or stupid. As Stankard himself said during an artist talk, once he was put in the "dummy class" and was told that he would never be more than a menial laborer when he left school. This perplexed his family, who put a high value on education and learning and became a great sense of shame for Stankard that lead to a lifelong struggle with low self-esteem and doubt. But Stankard, like many others with learning disabilities, was neither stupid or lazy — far from it, in fact. Despite the frustration he felt, Stankard never gave up trying to learn, a characteristic that he applied later to glass making and to the independent study of art history and literature. One bright spot in his stressful academic career was provided by a high-school teacher, Mrs. Reid, who read the classics aloud in class. Stankard could understand the spoken words in a way that he never could when trying to read something and this was confirmation to him that maybe he wasn't really stupid after all.

It wasn't until the late 1960s, through his sister Margaret who was studying Special Education, that the possibility of

Stankard's being dyslexic was raised. Knowing that there was a name and reason for his difficulties, that it was a disability, was liberating. Stankard was able to find the means to compensate for this and, as he notes, compensating for a disability can be a means of nourishing unique creativity, expression, and success.

Since those early days, Stankard's accomplishments, awards, and honorary degrees are legion. While many others have received honorary degrees in recognition of their accomplishments, for someone like Stankard, who overcame the challenges of his disability and far exceeded the expectations of his teachers, there must indeed be a special sweetness and sense of vindication with the stature that he has achieved.

In Stankard's life, the pursuit of excellence in glassblowing, lampworking, and creating his art has gone hand in hand with a lifetime of learning, and of *learning how* to learn. He cites early on that the first significant intellectual discovery he made was while in his first semester at Salem County Vocational Technical Institute when he realized that hand skills could be enhanced by studying technical information. Something clicked. It made sense. Theory and practice and their symbiotic relationship became manifest and clear.

After failing his first year of glassblowing at Salem, an incident that now brings about wry smiles and head shaking from any and all who have witnessed the miracles in glass that are Stankard's works, he eventually graduated and began a career as an industrial glassblower. In compensating for his dyslexia he learned, through watching other glassblowers, that observation was key for allowing him to incorporate new skills and techniques into his work. He became obsessed with making his work

the best it could be and that obsession has inspired and marked the work he has created throughout his life.

This obsession, however, wasn't motivated by a sense of personal glory or to satisfy ego. Stankard is a very devout, very spiritual man. Excelling at his work, making his art pieces the best that they can be, for Stankard is an act of prayer and a way of honouring the spirit of God in the best way that he can. His pieces — paperweights, orbs, and botanicals — are hymns of praise to the miracle of life and a celebration of the natural world that God has created. To create something that was second-rate or only mediocre would never be tolerated. And it is not surprising to learn that for many years in Stankard's studio a sign with the Benedictine motto "To Labour is to Pray" has hung above his workbench.

The journey from industrial/scientific glassblower to acclaimed artist was a long and challenging one for Paul. In the early years he and Pat were often living barely hand to mouth. And without Pat's unwavering faith in him and his art making, he would doubtlessly have considered pursuing a more stable, more traditional career in order to provide for his young and growing family. But she recognized, as did he, that residing within his soul was a desire to create, to be original, to find a means to express himself that routine and repetitive occupations would never satisfy. So together they chose the risk and path of art-making and adjusted their lifestyle to fit their means.

Stankard's story importantly includes anecdotes and references to the many artists, collectors, and dealers whom he worked with, who supported him, and who inspired him. Some readers may be inspired to research and find out more about some of

these people, such as Ida McCray, a friend and co-worker of Stankard's in New York City in the 1960s. An African American, she was the first female glassblower he had ever met and her highly skilled craftsmanship was respected throughout the glass department at Fisher Scientific. Others are well known and pre-eminent within the art world. Erwin Eisch, Arthur Gorham, Paul Hollister, Jr., Harvey Littleton, Reese Palley, and Frank Whittemore all figure in this tome. Stankard's initial encounter with Reese Palley is told with a gentle and self-effacing humour. When they first met, Stankard didn't know who Palley was and he passed up Palley's offer of an exhibition — something that Stankard quickly rectified! And Stankard pays loving and genuine homage to Palley several times throughout his story. Likewise, characters who wouldn't necessarily be known in the art world, but who were important to Stankard and his work, are remembered. Mike Diorio, a dentist and collector of paperweights, was also a photographer who took detailed shots of nature — roots and wildflower close-ups — that Stankard used as models when creating his work. Diorio passed away in 2001. Afterwards, to deal with his grief and to honour Diorio's memory, Stankard paid tribute to his friend by creating a paperweight titled "Mike's Heart."

In the 1970s, when Stankard began exhibiting and selling his work in galleries, the studio glass movement in the United States truly began. Stankard speaks of the arguments and debates that raged in the art communities of the times — of the heated discussions over what makes something art and what makes it craft. Are paperweights kitsch? Can works in glass be sculptural and part of the art historical tradition? Once, feeling

overwhelmed by the debates raging about him, Stankard asked Palley what he thought. The answer he was given was, *"Never let all that bullshit distract you. Just continue to make great work."* It was an era of great fired-up passion within the art world — and Stankard did exactly what Palley had advised by continuing to make great work and to make it meaningful, regardless of the category that others would assign it. Stankard's work pushed — and continues to push — the boundaries of fine art using a material normally associated with craft.

Stankard's achievements have come at a cost — for many years debt was his and Pat's constant companion and there was sacrificed time with his family. But no one can deny that his struggles were worthwhile ones. This autobiography is an honest capturing of his ongoing personal struggle to create the best work that he possibly can, to put aside his doubts and demons and to focus on what he knew was important and what he knew he was capable of achieving — regardless of what anyone else said. Stankard acknowledges this himself when he notes that *". . . art making is a spiritual quest, and is as close to prayer as one can get to glorifying the Almighty. Being an artist requires dedication and sacrifice as a calling equal to that of clergy."*

Ultimately, what anchors this story, with its many threads and layers, is love. Love of family, of art, of excellence, and of God. Stankard's story inspires, educates, informs, and entertains. When he was a student at risk of having to leave Salem County Vocational Technical Institute due to bad grades, the principal told him that he should quit school and join the army. Stankard said "No," because he knew that glass would be his life. Did that inspiration and tenacity come from such humble beginnings as a

child's encounter with a bonfire and a plastic rose in a glass bowl? Perhaps. Whatever the source of determination that allowed Stankard to realize some of the greatest art works of the twentieth and twenty-first centuries — regardless of medium — one can only echo and wholeheartedly agree with his mentor and friend Reese Palley who told him, *"Stankard, you should be making paperweights full time, and if you continue to do significant work, you'll be all right, and I'll guarantee it."*

Preface

Every Fourth of July, Papa would take us boys to the annual Attleboro Falls Firemen's Bonfire and Carnival. I always looked forward to going to this festival because there were so many games to play and, each year, the evening bonfire seemed to be bigger and more monstrous than ever before. When I was thirteen years old and went to this carnival, I discovered the most remarkable game booth I had ever seen. There, displayed on the side table, were red plastic roses, each one shimmering in its own glass bowl which had been filled to the top with water. I was fascinated by the beauty of the roses, magnified as they were by the water, so I decided to win one for my mother.

To get the rose, all I had to do was to toss a coin into one of the bowls. If I got the coin in, the bowl and its rose would be mine. Fortunately, the bowls weren't too far from where I was standing, and the somewhat constricted opening at the top of the bowl seemed large enough to hit with a coin. No problem, right?

To my surprise, however, the coin-toss turned out to be a lot more difficult than it looked, and after five frustrating attempts to get my coin in a bowl, I ran out of money. Papa came to the rescue and gave me another fifty cents and, when my persistence finally paid off, I walked away with my hard-won treasure.

I carried the prize around with me for the rest of the evening and, after the bonfire was over and we had returned home, I was proud to give the rose to my mother. She placed it on her dresser and it remained there for the next forty-three years — until the day she died at the age of eighty-eight.

I rediscovered that soiled plastic rose when my mother died, and since that time I have often found myself wondering about that night so many years ago at the Firemen's Carnival in Massachusetts. Is there any possibility that the vivid images of the delicate red rose encased in a glass bowl and the destructive yet awesome power of the bonfire — such contrasting forces of nature, yet juxtaposed in my experience — might have ignited in my subconscious mind the notion that flowers, glass, and fire could be brought together as one? Is it possible that in one magical moment in time, my destiny was sealed for life?

Fire and glass aside, my fascination with plants and their flowers began long before I won the plastic rose at the Firemen's Carnival. My mother told stories of how, as a child, I would eat the leaves off of her prized rubber plants, which, in turn, would prompt my father to insist that I had some type of vitamin deficiency. Other stories had me constantly picking the blossoms off of my father's cherished poppy plant, even while knowing that a harsh reprimand would always follow. To this day, my fondest

recollections of childhood revolve around how much I enjoyed playing outdoors and exploring the woods. Forever I will hold dear the memories of working in the garden with my father and grandfather and, as a Boy Scout, learning how to be self-reliant in the woods.

As I passed from childhood through adolescence and into adulthood, my life was complicated by difficulties caused by a learning disorder I had, but that went undiagnosed until I was well into adulthood. While I faced dissatisfaction and frustration daily with many aspects of my life, I also was constantly challenging myself to excel at much of what I could master and control.

Reading, one of the foundations of knowledge, was particularly difficult for me, whereas manual crafts were among my stronger areas of performance. In high school, I did well in woodworking and metalworking; at my vocational and technical school, I was introduced to glassworking; and when I started full time employment in the 1960s I found myself working in the scientific glass industry. Still driven both by a lack of satisfaction with what I was doing and, nonetheless, the need to excel at it, and gradually finding ways to acquire more knowledge, broader experience, greater satisfaction with my work, and increased self confidence, I found myself first being drawn toward working with glass as a craft and then toward the newly emerging studio glass movement. Still later, I became an integral part of the community of artists who had chosen to interpret and advance this beautiful and important new medium of expression.

Now, as a mature artist in glass, I can look back on the ebbs and flows of a life that has presented me with both challenges that have hindered my personal and professional development and blessings that have exceeded my grandest expectations. I

also recognize that I have been successful at overcoming many of the obstacles that characterized my early life, and have witnessed and taken part in the development of an art form that I dearly love and respect and to which I have devoted most of my adult life. Increasingly, I am moved to share my experiences and perspectives, mainly, I think, for three distinct yet inseparable reasons, and it is for these reasons that I have written this book.

I am privileged that my art is recognized and respected by artists, critics, and scholars internationally. My art is, however, but an expression of the natural world that I value, the standards of excellence in expression that I have set for myself, and the answers to my prayers that I can represent my values and standards in ways that will speak meaningfully to others. I am anxious to share insights into my life that can reveal the paths that I have taken, many of which are unconventional, in my journey from an underachieving dyslexic youth to my present position so that the purpose, content, and progress of my art making may be more completely understood.

I believe that the difficulties I faced in coming to recognize, understand, and deal with my dyslexia can be instructional and inspirational to others who might suffer from this — or some other — challenging personal circumstance. In this book, I speak of the limitations that my learning disorder imposed on me, the opportunities that it placed — or nearly placed — beyond my reach, the meaningful revelations that came my way, and the milestones I passed as I sought and recognized and adopted methods for educating and improving myself. It is my prayer that my experience can inspire others with personal challenges to pursue their dreams and to persist in that pursuit until those dreams are realized.

My background, and the pathways I took to become an artist in glass, are unusual among most fellow glass artists of my generation — itself the pioneering generation of the art form. Being employed in industrial glass as the studio glass movement began to materialize in the university art school environment, I was outside of the contextual, conceptual, methodological, and practical universe in and of which the movement itself was born. Yet, I sensed and was motivated by the creative potential within this new and vibrant movement, and I was challenged to adapt the methods I knew and skills I possessed in ways that would allow me to express myself at the level of excellence required for my glass to become art. With effort and opportunity, my work became accepted as art and I became accepted as an artist, stature which allowed me the further honor of participating in the establishment and strengthening of educational programs and organizations that celebrate and advance the appreciation and progress of art in glass. In the pages that follow, I provide insights into the history of glass worked as craft/art and the studio glass movement as I have witnessed and experienced them during the past forty-five years.

Collectively, I hope that *No Green Berries or Leaves* will inform and inspire others who might be interested in knowing about the personal side of an artist's life and about that artist's view of the recent birth and development of glass art in America.

Acknowledgments

This book would not exist without the intellectual and emotional generosity of my dear friend Judy Moore. As editor and tutor, she guided this inexperienced, dyslexic author along a path wrought with challenge and joy and helped immensely to craft

the book that is now before you. Her generous heart has allowed me to share my story of overcoming failure and misery in school to achieve international stature in the arena of American art. Thank you, Judy Moore, for your patience and kindness and for bringing your high literary skill and standards to this project.

I also wish to acknowledge the invaluable assistance of Robert Martin Stankard, my brother, who helped in inumerable ways with this project; Jillian Molettiere, my assistant; Henry Halem, who read and critiqued the final manuscript; and Peter Kwok Chan, who designed the text layout and covers. For assistance in numerous ways, I extend my very special thanks to Marcia Abramson, Robert Bowe, Robert Brill, Susan Gogan, Alexandra Grilikes, Susan Guinan, Jon Kuhn, John Lang, Bonnie Marx, Robert Mickelsen, Jim Moore, Tony and Maggie Parpusi, Richard Rosenfeld, Margaret Stephen, Barry Zuckerman, and members of the Corning Museum of Glass's Rakow Library staff.

Lastly, I wish to acknowledge two of my dearest friends — Dr. Michael Diorio, 1936–2001, and Martin Abramson, 1945–2007. I present this book as a tribute to their memory.

Photographic Credits

The photographic essay that appears near the end of this book contains several images that were provided by friends, colleagues, and supportive organizations, and I am grateful for their assistance and generosity. The sources of these photographs, identified in parentheses by plate number and position on the page, include James L. Amos (VII: all; VIII: top left and right, bottom; X: top left and right; XVI: top right; XVII: left top and bottom; XVIII: top, left; XXII: top, bottom; XXVI: all; XXXI: all), Carol

Bates (XXIII: top, middle left and right), Robert Bowe (XII: middle; XIII: top), Corning Museum of Glass (XIX; XXIV: top left and right, bottom left), Mike Diorio (V: lower right; XVI: top left; XXI: bottom), John Healey (XXX: top), Mike Hogan (IX: bottom), Jillian Molettiere (XIII: bottom), Museum of Glass (Tacoma) (XX: top), Muskingum College (II: bottom), Reese Palley (IX: top left), Mark Peiser (X: bottom), Penland School of Crafts (XII: top, bottom; XXIV: bottom right), Jennifer Richard for Team Photogenic (XX: bottom), Miriam Rosenthal (XXI: top), Salem Community College (V: top; XIV: all; XV: all), Douglas Schaible / Schaible Photography, Inc. (XXVII: all; XXVIII: all; XXIX: all; XXXII), Ivan Scott (II: middle), SOFA Chicago (XVIII: bottom), Joseph Stankard (XVI: bottom left and right; XVII: top right, middle right; XVIII: lower right; XXII: middle left and right), Pat Stankard (XXIII: bottom), Joshua Steindler (XXV: all), and WheatonArts and Cultural Center (XI: all). All images that are part of the mosaic on Plate I were provided by the photographers and institutions just named.

The photographs of paperweights that appear within the text were taken by Joshua Steindler.

I Have Two Names

I concluded my address by telling my audience that I thanked them, that my mother thanked them, and that my father thanked them. I then returned to my seat in the midst of a standing ovation from the audience that had filled Brown Chapel to its limits.

The date was May 3, 2007. I had just delivered my commencement address to the graduating recipients of the Masters of Arts in Education and in Teaching degrees at Muskingum College in New Concord, Ohio. I also had just realized a high personal honor and had just passed a major personal milestone. As a mature artist with significant interest in education, I greatly valued the prestigious opportunity to share some of my deepest personal thoughts and experiences on the nature and value of education with those who will follow their calling to teach and, as a result, will touch the lives of thousands of students. As a human being who has had a lifelong learning disability, however, I also

was satisfied beyond description with having just successfully read my first formal public address.

I had been thrilled when Dr. Anne Steele, President of Muskingum College, invited me to give the commencement address to the Graduate School of Education's Class of 2007, but I also felt distinct anxiety about making a formal public speech – one that I knew I would have to read. I had always looked forward to the possibility of having the opportunity to provide a commencement address to college graduates because I believe strongly in the importance of education and I know, personally, the great value of an education and the influence it can have on each and every life. At the same time, from my earliest years in elementary school, I have had great difficulty reading, especially out loud when others could sense the difficulties I was having, and I recall numerous instances of having been humiliated when trying to read in the presence of others. As a result, I have a continuing fear of making formal public presentations that might require reading from notes or a prepared text, and in order to deal with this I have resorted to either, or both, memorizing my presentations or speaking extemporaneously. In these situations, if my memory were to fail me, I would be in trouble because I would not be able to read from my notes or text. I am dyslexic.

Even though I know that dyslexia is not an uncommon learning disability, I still find it difficult to be completely candid with people about the fact that I have it, and especially to tell them that I cannot read, spell, or write well. Yet, over time, I have become less self conscious of this disability because I am able to stay focused and I have been determined to use the normally functioning parts of my brain to outwit its dyslexic tendencies. But this has not always been so.

§⬥

When I was a young schoolboy I had no idea that there was anything wrong with me. I knew I wasn't reading or doing math as well as the other kids in my classes, but I thought that someday I would catch on, catch up, and then everything would be all right.

In the 1950s, the good sisters of Saint Mary's Parochial School managed their classrooms with loving kindness — and a wooden pointer — but as long as an underperforming student such as me was well behaved, he or she was left alone. I was reminded frequently, however, that I was a slow learner, and the reinforcement of this idea gradually convinced me that I was stupid. I developed a lack of confidence and a sense of low self-esteem, and this circumstance, in turn, further inhibited my academic performance. I failed the third grade and was put on probation in the fifth grade, and my mother had to tutor me at home on school nights. And as strange as it might seem, I was jealous of the smart kids.

Reading was a particularly unpleasant form of torture for me because I was constantly being corrected for repeating the same mistakes. Simple words like "was" I read as "saw," and I couldn't distinguish "N" from "M," and so on. In math, I transposed numbers, and the most embarrassing deficiency was not being able to distinguish right from left. When I was in the seventh grade, I made my right index finger raw by repeatedly scratching it in order to feel my right hand. My parents thought that I had a nervous tick and would constantly tell me to stop picking at my finger.

I found high school to be comfortable in a strange way because no one had any academic expectations for me. The courses

that I loved most were those in the industrial arts, and I earned Bs in woodworking and metalworking. I also excelled at running track, and with success in some courses and athletics, my self-esteem was enhanced.

One particularly bright spot in my education came when I was in high school from Mrs. Reid, my English teacher for three consecutive years. She would often read the classics out loud to the class for fifteen to twenty minutes at a time. When I heard her spoken words, I could both understand what they meant and appreciate their meaning, an experience that was so much different than having to read, and then understand, the printed words myself. Mrs. Reid's practice of reading out loud, a simple teaching tactic, allowed me to experience and appreciate knowledge in a way that I simply could not have done otherwise. I didn't realize it at the time, but Mrs. Reid had presented me with a method of learning that would, years later, change my life dramatically.

In retrospect, however, most aspects of my formal education, at least through high school, were frustrating. I did not do well in the three Rs and that limited my abilities in many other subjects and endeavors. But, I realized I needed to function in a society where most people could read, write, and apply basic mathematics, so I worked hard to devise alternate ways of overcoming my limitations, becoming competitive, and finding an acceptable level of personal satisfaction. In order to appear as literate as possible, in my wallet I carried slips of paper with everyday words printed on them, words such as the days of the week, the names of the months, and certain important numbers. One had my middle name written on it; I was unable to distinguish between Paul Joesph and Paul Joseph. Nonetheless, I

continued to have trouble with letter sequences, especially with spelling; I frequently transposed numbers; and, worst of all, I was often not able to respond to instructions that included having to differentiate between right and left.

All the while, I was an inquisitive and eager go-getter, and these positive aspects of my personality helped me to get along well with others and to secure numerous odd jobs. Those who employed me praised my entrepreneurial spirit, and my parents were fast to applaud my work ethic.

In the late 1960s, my sister Margaret, who was majoring in Special Education at West Virginia University, came home for a visit. One afternoon while she and my mother were having a conversation at the kitchen table I walked in, sat down with them, and began fumbling with the daily newspaper. To this day I don't know what compelled me to do it, but out of the blue I just started reading the headlines of the paper, stumbling miserably on each written word. All my mother could say was, "Paul has always had trouble reading," while Margaret, appearing somewhat distressed by my inability to read, suggested that I might be dyslexic — whatever that meant. I didn't act on Margaret's advice about getting some help, so for the time being that was the end of that.

The topic of my dyslexia remained dormant until about three years later when I happened to turn on the radio and heard Phil Donahue interviewing Olympic gold-medalist Bruce Jenner, who was discussing how he had been diagnosed with dyslexia while in middle school. I immediately wrote to the station and requested

a transcript of the show, and after receiving it I listened intently to every word on the tape. Dear Jesus! Bruce was describing me. Perhaps there really was a name for what was wrong with me; perhaps there was a cure; and most importantly, after all these years, perhaps it meant I really wasn't stupid. After learning there was a neurological basis for my inability to process information like most people, and after coming to understand part of the nature of this problem, I decided that I had no other choice but to accept what I saw as a reality and do the best I could with the abilities that I had been given.

One significant step in my dealing with dyslexia came in the mid-1970s when I became aware of the Franklin Mint's collection of audio cassettes called "The Greatest Books Ever Written." I subscribed to this series and soon found myself engrossed in listening to the books as soon as they arrived, and I eagerly awaited each new quarterly installment. Mrs. Reid's reading aloud had stimulated in me an interest in literature as a celebration of the spoken and written word, and Franklin Mint's collection allowed me to become familiar with so many of the world's great literary works — those from Homer to Walt Whitman to James Joyce. The discovery of audio books has tremendously broadened my world view. In addition, becoming acquainted with the great literary works has challenged me to take creative risks and seek out the same depth of human emotion in my art that I feel from the great books.

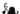

Over the years, the hardest part of my journey has been to reassure myself that I am not stupid. However, I still find it difficult

to dial phone numbers, I still have to recite the entire alphabet to get a correct sequence of letters, I still get uneasy when I am asked to autograph and inscribe a dedication for fear of misspelling words, and reading still demands absolute concentration and focus.

In retrospect, during my school years, being relegated to the lowest level of achievement with no expectations placed upon me put me in a strangely comfortable situation. With no one demanding much from me, I forced myself to develop unusual strategies in order to perform ordinary tasks, all of which eventually helped me to get where I am today. As a mature artist, I now recognize one of life's greatest ironies — the fact that a disability can give one the strength to compensate for the disability in ways that can, in turn, nourish unique creativity and success.

Life is always full of amazing surprises, and some of the more interesting and ironic for me have occurred during the past ten years when I and my accomplishments have been recognized by educational institutions. In May of 1997 I received an Honorary Doctor of Fine Arts degree from Rowan University in Glassboro, New Jersey. Eight years later, I was inducted into the first class of the Visual and Performing Arts Hall of Fame of my alma mater, Pitman High School, located in Pitman, New Jersey. Then, in 2007, I was awarded a second Honorary Doctor of Fine Arts degree, this one by Muskingum College in New Concord, Ohio. Reflecting upon these and other honors, I find pleasure in recalling my mother's frequent chant, "If at first you don't succeed, try, try again."

My dream is that this story will encourage people with learning disabilities who struggle in school to know that they can learn

by caring about what they do, and by doing it well. In other words, by doing things well, one can educate oneself and enhance self-esteem while contributing to society.

I hope those who read this book will find interest in the story I have to tell. And for those who have been told they are different, think of that difference as a blessing and never give up because, in the end, perseverance can only enhance one's creative potential and future. No one said it was going to be easy, but with a supportive wife, a computer with spell-check, determination, and editorial help, even a dyslexic like me has written a book.

Learning Scientific Glassblowing

The Stankard family moved from North Attleboro, Massachusetts, to Wenonah, New Jersey, in 1958. My older brother Martin and I rode the train to our new house while the rest of the family traveled by car. Later, our father related to us the story about having stopped at a service station on the New Jersey Turnpike. While making small talk with the attendant, my father mentioned that he had been transferred from his job in Mansfield, Massachusetts, to one in Gibbstown, New Jersey. As the car pulled away from the station, the service man, who must have noticed all of the little faces looking out of the car window, was heard to call out, "Another car load of Irish for New Jersey."

I was fifteen years old when we relocated to Wenonah. At the time, I thought this move was some kind of bad dream or harsh punishment. Home to me was a small town in Massachusetts, surrounded by woods where I could nurture my love of the natural landscape. But in Wenonah, I faced the tough transition

of going from being a popular kid with a promising future in long distance running to an anonymous outsider, a measly sophomore with a strange accent. I had no friends. For the first few months, whenever there was tension between me and my parents, I would needle them by yelling, "I'm leaving and going back home." For a while this threat was a very effective tool at getting my way, but I never left New Jersey.

During my senior year at Pitman High School, which turned out to be a socially successful one, I had to make the required trip to the guidance counselor's office to discuss my future. Earlier, I had indicated some interest in attending a technical school so the counselor was prepared and handed me some information about Salem County Vocational Technical Institute, now named Salem Community College. That evening at the dinner table I handed a pamphlet to my father and commented that I wanted to become a machinist, but what I will always remember most was his enthusiasm about the glass program that was mentioned in the brochure. My father, a chemist, was a very stern and introverted man, so his uncharacteristic eagerness for me to explore scientific glassblowing encouraged me. I had previously completed a research paper on the history of American glass, so I had a little background within which to consider his suggestion. A short time later, when I told him I was interested in looking into Salem's glass program, he took an afternoon off from work so that we could visit the school together.

Seeing Salem's glass facility was exciting, and as I watched the students bend their glass tubing in the threatening flames I realized they were doing something that was both mysterious and thrilling. In my imagination I could almost see my future. After

talking with an admissions counselor, I enrolled in the program. One of the greatest things about attending Salem was the school's open-door policy, which meant I didn't have to take any entrance exams. If I had, I probably would never have been accepted into their scientific glass program. Because of Salem's open admission policy and the opportunity it gave me, I have always felt a sincere debt of gratitude to this fine institution. My glassblowing education began at Salem in September, 1961.

I was the second oldest of nine children and we all knew that money was tight and it was our responsibility to help with the family finances. Even so, my parents had told me they would pay for my education, but I was a hard-working teenager and had saved up enough money to pay for my own tuition, which I did. When my father would praise my efforts I was filled with pride, and even today I can recall and be moved by his words of encouragement.

When I was eighteen years of age and still a senior in high school, I wanted to be independent of my parents' supervision, to avoid their lectures about studying harder, and to know that my mother wouldn't be checking and re-checking my homework every day. I was determined to have full control of my educational success; it was going to be my responsibility to pass or fail.

The first milestone in this evolving independence was, of course, to finish high school, which I did — barely. About an hour before the end of my senior year I learned that I held the dubious distinction of being ranked near the bottom of my class. I thought that this dismal information was rather funny, yet I

wondered — obviously a little too late — if I could have done just a little bit better in school. Even though I believed I was neither stupid nor lazy, words that had often been used to describe me in school, my class standing seemed to imply that they might have been right. Needless to say, I was glad to leave my reputation at Pitman High behind me.

That summer of 1961 I worked a lot of odd jobs and during my spare time I tried to find out all I could about scientific glassblowing in preparation for the fall semester at Salem. After classes started at Salem, my old man, as I sometimes affectionately referred to my father, gave me two dollars and fifty cents a week for car-pool expenses, while mom would give me an occasional five dollars for "treats." This extra money helped with expenses, but not having a car became my biggest challenge because, without a set of wheels, I found myself having to hitchhike the eighteen miles home when I would miss my usual ride. I didn't like thumbing at all, but in rural South Jersey in the early sixties a student with books under his arm could easily get a ride.

During my first class in glassblowing, our instructor, Mr. Hunter, demonstrated some glassworking techniques by making a swan, and after seeing the hot flames and glowing glass I knew this class was the one for me. Before long there would be talk of how glassblowing was a closely guarded secret and of how Mr. Hunter was breaking with tradition by teaching kids like me these techniques. These stories added intrigue to the course, which gave me even a greater desire to learn more about this ancient craft.

My first lab in this course consisted of learning how to turn on the torch and light the flame with a match. Being a smoker, striking a match was effortless, but it took me a while to figure

out how to prevent the natural gas from escaping into my workspace. Once that problem was solved, my biggest obstacle was dealing with the bench torch backfiring when the oxygen was introduced to the flame. What scared me the most about backfiring was seeing the fire flash light up, then instantly expand, the rubber hose that was snaking under the bench. The school had single-stage pre-mix burners with a #3 tip, and when I adjusted the flame I could see the gas sinking into the tip of the torch and then — Bang! The noise was worse than that of a loud firecracker. There were eighteen students in the class and during the entire first week I was in a perpetual state of anxiety from the constant barrage of backfiring. But just at the point when I thought my nerves would permanently suffer from the noise, I figured out what I had been doing wrong, corrected my mistakes, and felt as though I had finally jumped a major hurdle. Up to this moment it seemed as if I had been doing everything the hard way, so my discovery that there was a right way, an easier way, was a confidence builder.

Eliminating the backfire also solved much of the problem of having the entire lab saturated by the strong smell of garlic. Mr. Hunter later told us that the South Jersey Gas Company added liquid garlic extract to the odorless natural gas so users would know when the gas was in use.

Melting and pulling straight points on glass tubing and then sealing two tubes together without burning myself became my next challenges, and before long I was able to measure my progress. A good day would be to finish my lab in three hours without having cracked or devitrified a piece of glass. For the most part, the basic techniques of working the glass were difficult to

learn, but after I mastered even the smallest skill sometimes I would go off on my own and make little glass creatures so that I could have something to show for my hard work. I loved every minute spent in the glass lab and never missed a class that entire year.

Unfortunately, the academic side to of my formal education was another story. Two weeks into the program I remember saying to my brother Martin, "Classes are hard at Salem. I can't read too well, but I love learning glassblowing." By saying these words out loud, I realized for the first time in my life that my poor reading skills were probably going to hold me back from any type of a productive future, especially one in glassblowing. Martin seemed to understand how much I really needed help so he gave me some advice on how to improve my reading comprehension. "Don't read a new paragraph," he said, "until you understand the one you've just read."

Disciplining myself to read every single word rather than skipping over words in a sentence was something I had never done before. Usually, when I read, I often overlooked words I didn't know or I misread words without knowing I was making a mistake. My ability to read had been based on twelve years of memorizing what certain words looked like as a group of letters. In my mind, words were not sounds connected, but rather symbols that had meaning. Forcing myself, to actually learn how to read and then to focus on the process would become one of the most difficult tasks I had ever undertaken, but I was determined to try.

To my advantage, I had a strong vocabulary because of my audio memorization skills, but I had to say the words out loud in

order to understand what they meant. To put it another way, I had to hear how each word sounded and then I would grasp its meaning. However, in order to understand most of the written words I was now encountering at Salem, I had to rely on my seldom-used dictionary.

I wasn't able to organize letters alphabetically, so when I needed to look up a word in the dictionary it would take me quite a while to find it. For example, if I needed a definition for "oxide," I would start at the beginning of the dictionary and move forward until I found the letter "O." Then I would keep moving page by page until I found the "ox." Finally the word "oxide" would appear. I would say "oxide" out loud so that I could hear it, and then I would move on to another laborious word search. Quite often it would take me hours to read three or four pages, but in time my ability to read began to improve. For the first time in my academic experience I had found a way to complete my course assignments, regardless of the time involved. I felt as if I had conquered the world.

Toward the end of my first year at Salem I was summoned to the office of the Director, Mr. Donaghay, and told that my grades weren't good enough to allow me to stay in Salem's glass program. Mr. Donaghay said I had failed algebra and my major subject, scientific glassblowing, and then proceeded to tell me that the best thing to do would be to leave school and join the army. Shocked and stunned beyond belief, my protest was immediate and passionate; I pleaded and insisted that Mr. Donaghay give me another opportunity to stay in school so I could continue glassblowing. After what seemed like a very long deliberation, he decided to place me on probation and told me that any further

decision about my status would be postponed until the end of the third semester. I was surprised by my emotional outburst — and thankful to have been given a second chance.

Despite my miserable record, I had learned something fundamental during my first year at Salem. The idea that hand skills could be enhanced by studying and acquiring technical information was a concept I had never grasped before, but it would prove to be my first significant intellectual discovery at Salem.

During that summer of 1962 I found a job as a glassblower and worked at it about forty hours a week. I loved the different tasks involved and was skilled enough as a production glassblower to earn a raise after working just over two weeks. The owner of the company, Bob Work, had learned his craft at the Mobil Research Center in Paulsboro, New Jersey. And after twenty-two years of scientific glassblowing he had left Mobil to start his own business, the Robert Work Glass Company.

Mr. Work was a master glassblower who zealously stressed quality as if he were promoting it as a religion. He taught me to respect workmanship and safety as integral parts of the glassblowing process, and he introduced me to the celebratory attitude of "getting it right." His words became the bedrock and platform that have kept me striving for excellence ever since. While working at this job and in this environment, I acquired a higher level of hand skills than I possessed when I started and considerably expanded my practical knowledge of glassblowing.

The opportunity to assist skilled masters in a professional environment during the summer gave me an advantage over the other students as I began my second year at Salem. I was now taking a full academic load, which included having to re-take my

algebra course, which met two nights a week, so I could graduate in the spring. As luck would have it, after finishing my algebra class, I was able to visit the ornamental glass class being taught by Francis (Frank) Whittemore, who would let me hang around while the class was still in session. After Frank's class was over, we would talk and he would tell me great stories of those creative people who had mastered glass lampworking techniques and of Charles Kaziun who had built a career out of making paperweights.

Frank was a scholarly type who had left Harvard University to join the army during World War II. When his tour of duty was over, the DuPont Company hired him to work in their scientific glass facility. He had a vast knowledge of glass and over the years he would master his craft as a research glassblower. In time, he would leave scientific glassblowing to become a master in creating lampworked paperweights and glass miniatures for doll houses.

Sooner or later it was bound to happen; I found out the hard way the cost of being careless. In the middle of my second year at Salem, I was pushing a cork stopper into a 25-mm glass tube when excessive pressure built up and caused the glass to break. Instantly, a sharp edge sliced into my left index finger, deep enough to nick the bone, and after seeing the blood flow down my wrist I retreated into prayer, practicing a contemplative technique a nun had taught me years ago. The injury looked fairly serious so Mr. Hunter drove me to the hospital, whereupon the finger was washed, disinfected, and stitched closed. Later, the doctor made

a comment about how fortunate I was to have avoided permanent nerve damage, and as a result, this episode marked the beginning of my spiritual respect for, and awareness of, the potential danger of working with glass. The fear of doing permanent damage to my hands forced me to consciously confront what I intuitively should have known — that there are safety limits for handling such fragile and potentially dangerous materials.

By the end of my third semester the hard work had paid off and I had a B in scientific glassblowing to show for it. With each day's passing I was becoming more confident in my ability to master technical glassblowing and I even began to believe that someday my future could be secure within the trade. Or better yet, that I would be able to use my skills in some creative way. But for now, between school, part-time work cleaning Mr. Work's glass shop on Wednesdays, blowing glass on Saturday mornings, and going out with my new girl friend, I was a busy guy.

Getting to know Patricia Ann La Patrick was electrifying, and looking back now I believe our first few dates were the happiest times of my life. I had met her at a dance when she was a senior in high school, and during that evening, we had a Coke together at the dance canteen. She set off every one of my bells and whistles. Pat loved art and was quite gifted in drawing. Her talent was formed by countless hours of drawing as a child and the art lessons she had taken throughout school. Soon I began showing her my creative glass pieces and her enthusiasm and support were wonderfully uplifting. Later, when she discovered I had problems with homework and other school assignments, she didn't mind spending time in the library giving me some much needed help.

In the spring of 1963 I graduated from Salem County Vocational Technical Institute, and that summer I asked Pat to marry me. She said "Yes!" I had just taken a job with Macalaster Scientific Inc., located in Nashua, New Hampshire, but Pat would be staying in New Jersey to work as a secretary for the Campbell Soup Corporation. Thus, we would be separated and facing an interesting long-distance love affair. Writing letters to Pat on a daily basis was one of the most challenging things I ever did. Surely, Pat realized that my writing skills would never rival those of Walt Whitman, and to this day I am amazed that she didn't cut me loose.

My interview with Macalaster had gone well and I was offered a position that would pay one hundred dollars per week, a wage I thought to be pretty good for my first real job, and then I was promised a review in three months that might lead to even higher wages. Wasting little time and eager to be on my own, I left for Nashua as soon as school was over at Salem, not even waiting the additional week to attend my graduation. I did, however, ask my parents to take care of my diploma when it arrived in the mail.

I was quite interested in my new job both because my mother's family had lived in Nashua for generations and returning to New England had been one of my top priorities since the day I left Massachusetts five years earlier. Moreover, Macalaster Scientific was known for its wide production of assorted laboratory glassware and for me to have experience in this area would complement my ultimate goal of working in a research environment. So, taking my first full-time job with this company would not only give me the chance to return to my roots, it would afford

me the opportunity to improve or even master new hand skills in glassblowing.

The rhythm of the first couple of weeks in New Hampshire centered on my work and writing my daily letters to Pat, informing her each day of what I was accomplishing. Yet, living on my own for the first time was difficult because I was lonely and flat broke. Also, I didn't have a car, and that doomed me to hitching a ride to work with the shipping clerk who lived near the Victorian boarding house where I was now residing — along with three other men, all in separate rooms. For me to have had my own car would have meant that my father would have to co-sign for my insurance, but he wouldn't do this because he thought it would be too much of a liability. To be honest, as much as I wanted my own car, I wanted to be independent of my parents even more, so I ignored the issue and decided to wait until I was twenty-one to buy my first clunker. Consequently, in order to see Pat, I took the bus back to New Jersey about every other weekend, but being with her for just a day and a half was well worth the 690-mile, fourteen-hour round trip.

My next biggest personal challenge was to look at food as a basic necessity. Because of my limited finances, mealtime was nothing special. My diet wasn't great, but it got me through the day. During the nine o'clock coffee break I would eat a couple of hot dogs, then drink a quart of chocolate milk, which I purchased from the Chuck Wagon that showed up at Macalaster's side door every morning. Gourmet cooking it was not, but this meal made up for my not having dinner the night before. At lunchtime I would down a few sandwiches with another quart of milk to hold me over until the Chuck Wagon rolled around again the next day.

After all, there were living expenses and those long bus rides home were costly. In addition, my hoped-for raise didn't materialize. So, for a while, eating remained a necessity, not a luxury.

My first assignment at Macalaster would become ironically poetic. I had been given 12-mm glass tubing to heat, bend, and shape on a ribbon burner. These became the pieces of curved glass used on hummingbird feeders. It was exciting to be paid for perfecting a basic glass-working technique on this new type of equipment, and I gained some extra confidence knowing I had done an expert job on my first assignment. It is interesting to remember, some forty years later, every nuance of that first specific task.

I ended up bending glass tubing for a couple of weeks, and with my skill level improving each day I became less stressed and less fearful of doing a poor job. As my internal pressure subsided, I started learning my way around the factory and took time to become better acquainted with several of my co-workers. The first thing these guys taught me was that professional glassblowers did not wear neckties to work, so off came the one I was wearing and, almost immediately, I began to feel accepted.

The next five months at Macalaster were filled with interesting assignments, and I found myself learning and perfecting new techniques with the help of four highly skilled craftsmen. Yet, there was no question that the tasks I was assigned here were a lot more complicated than were those at Salem. At Salem, we would watch Mr. Hunter demonstrate a particular glass technique and then we would go back to the bench and practice the lesson. At Macalaster, if you were assigned a job or if you had any questions about form or a new method, the foreman would

help you out, but you were expected to have the skill and the ingenuity to complete the task on your own. Here, demonstrations or long explanations were rare.

For me, being able to work with skilled professionals and being discreet while watching them perform advanced techniques was like learning by osmosis. It was a very effective way to internalize the glassblowing process. Observation, then, seemed to be the key that allowed me to incorporate new skills with the basic techniques I had learned in technical school. Subsequently, each day I became more fascinated with the process of making things well, of doing the job right, and of committing myself to becoming a master in scientific glassblowing.

Even today, I still believe the art of glassblowing is perfected on a personal level by a commitment to the technique, where the process is internalized into a personal rhythm and power of observation. In industry, especially in production shops, one is given an assignment closely related to a technique he or she has already perfected. This makes developing new skills a big challenge. One way I learned new techniques was to stand next to a master while making small talk and watching him work. The benefit of being able to see work in progress, even if only for a few minutes, is usually all that is required for learning.

For the most part, Macalaster was a dark and dingy place, but having nice people around made the work environment more pleasant. I would ask the other craftsmen questions about the nuances of their different glassblowing methods, about their feelings of getting things right, and about their genuine enthusiasm for their craft. When it came to work, it was inspiring to be near co-workers who were making the glass come alive, as they made

each difficult maneuver look effortless. In addition, I was continually awed by their level of success and I respected and even marveled at their skills. As the youngest glassblower, my goal was to emulate their moves, which appeared to be more magical than technical.

One of the apprentices I was working with, Roland "Rick" Ayotte, had a high energy level and an up-beat personality, qualities that were counterpoint to the stress of the job. After only a couple of weeks we had become good friends. Soon afterwards, we were hanging out together a couple of nights a week, celebrating life as only young men could do. Rick also had a tight circle of friends in which I was now included, and for the first time in a long while I finally felt a sense of belonging.

When we weren't with the gang running about town or loitering around a new fast-food stand, Rick and I would talk about glass. Our main topics of discussion centered on different types of tools and equipment and of our mutual fascination with ornamental glass. We were both dedicated to mastering our skills within the industrial setting, but at the same time we shared a strong creative impulse that could not be found in scientific glassblowing. I don't know about Rick, but working with glass had finally given me a sense of purpose. I felt as if I had finally tapped into a culture that required a very esoteric education, a Zen-like quest of quality, and an understanding of the reasons for making objects well. Increasingly, I was developing a new belief system, the core of which was respect for working with my hands, while at the same time being productive.

By October, work was beginning to slow down so I was assigned to do production inventory, which was boring to me

since these tasks were now below my skill level. There were rumors of layoffs, and after mumbling something to the foreman about my incredibly boring assignments, I was surprised when he shot back, "You're lucky to have a job!"

I was laid off the next day. Rick kindly drove me to Boston's Logan Airport for a flight to Philadelphia and, when I arrived back home, Pat was there to greet me. After telling her what had transpired she just shrugged her shoulders with indifference. Her unwavering confidence in me became a new and wonderful feeling for me to internalize. Right then and there, I knew that with her steadfast support and my commitment to working with glass, together our future would be all right. In retrospect, as I think about that long ago chapter in my life, I marvel at how easily we accepted life's obstacles and uncertainties.

My Small Bite
of the Big Apple

I had left New Hampshire on a Friday and the following Monday I was on a bus to New York City in hopes of finding employment. Upon arriving at the Manhattan Port Authority, the first thing I did was scan the phone book for scientific glass companies. There were about five listed, but my first choice was a small glass shop that had a Mercury Diffusion Pump as its logo, the pump indicating glass manufacturing. I immediately called this company and was given directions to its location in Queens.

I took the subway to Queens, and spent most of the ride worrying about having to fill out the application forms since having to read and write for others was always emotionally stressful to me. In order to make my personal anxieties less torturous, I decided I would ask for two application forms, one as a backup in case I made errors or was overly sloppy on my first attempt. Once at the glass shop I had no trouble finding the owner, who was seated at his bench just finishing a ring seal. While the glass was

being flame annealed he began asking me questions, and during the casual interview I discussed my prior education and my past experiences in working with glass. As it turned out, he was only interested in hiring a beginner, but he did mention that the Fisher Scientific Company was looking for more advanced glassblowers. In a gesture of kindness, he called Fisher and got me an interview with them the next morning.

I caught the subway back to Times Square and when I ascended from the dark tunnel with my small suitcase in hand I was struck by a pang of loneliness I had never encountered before. With its dynamic, intense pace, its colossal buildings, and its overwhelming sounds and smells, the city not only intimidated me, it made the world around me seem eerily surreal. At the same time, however, I felt surprisingly comfortable navigating the New York subway system, something I thought would have been totally confusing to me. My first impression of the city was that it was a strange place for me to be seeking fame and fortune.

A nearby policeman gave me directions to the local YMCA on 34th Street, between 8th and 9th avenues. Needing a place to stay, I found the Sloan House to be a great value. For a dollar-fifty per night I was able to rent a small room, not much larger than seven by twelve feet, with the shower and toilets down the hall. After getting settled, that evening, with the help of a dictionary I had purchased that afternoon, I used one of the application forms I had picked up earlier for practice. Also, later on that evening, I called Pat to double check some of my spelling. With correct spelling and my cheat-sheet to guide me, I was starting to feel somewhat more confident about going for my interview the next morning.

It was an easy ride to Greenwich Village where Fisher Scientific was located, but I had been unbelievably amazed by the sea of humanity that surrounded me on the subway and on the two-block walk to the factory. Once the interview began things proceeded rather smoothly, and after telling the manager about my technical education he immediately sent me to another area for a dexterity test. I was given a piece of glass and was told to pull several points from 25-mm tubing and then to make a "T" seal and bend the tubing at a right angle. Within ten minutes, Fritz Newburg, who was evaluating my performance, stated in his thick German accent, "OK, mister, you can turn off the torch. You'll do fine." Back at the manager's office I learned that I had been hired and was expected to be at work the following morning. I suppose my "getting it right" was beginning to open doors to broader opportunities, and I was happy to be employed.

For the first few weeks the foreman's assignments were quite easy, then they became progressively more demanding as he tried to determine where I should be placed within the union hierarchy. The union scale included four levels — apprentice, third class, second class, and first class — and each level had three divisions. I was rated second class, middle division, and that rating qualified me for a wage of $110 per week. After a month's probation, I would be eligible to join the union and would be given a two-and-a-half-percent raise. Although some of my fellow workers were jealous of my salary, I symbolized the advantage of having a technical education, the future of scientific glass technology.

I was both thankful for and in high spirits with my new job. Working with my hands and knowing I was good at lampworking

gave me a great deal of satisfaction. At Fisher, most of my assignments involved three to five days of work, with the number of pieces I produced numbering in the dozens. It was a little daunting at first as I tried both to focus on technique while also increasing my production rate. To keep my tasks interesting I would make each assignment a personal competition, and within a couple of weeks I was making progress with my speed and accuracy. In time, though, the work became mundane and the repetitiveness led to boredom, yet I couldn't help but notice the other skilled glassblowers who were always exhibiting patience and pride in their work. I'm glad to say that in the long run their sense of well-being and the aura of dignity that surrounded them motivated me to improve my attitude.

Most of my co-workers were foreign born and spoke English as a second language, and more often than not I was flattered to be the one who they called upon to answer their questions about American culture or to give them advice on other trivial matters. In addition, I felt fortunate to be working with these fifteen or so glassblowers from different countries, all having experienced a variety of glassblowing styles from varied European glass companies. For someone like me just starting out, this exposure was a valuable and rare opportunity to become familiar with new ideas and techniques.

During my third month at Fisher there was a shortage of skilled glassblowers, so I was given an ambitious assignment to make custom glass apparatus for Saint Vincent's Hospital in midtown Manhattan. This job was my first professional challenge that entailed making an assortment of complex ring and side seals, a perfect opportunity for me to develop new skills and more

confidence. I would be making twelve units and each would take three to four hours to finish.

It takes time to learn new techniques in a production shop environment, and even though everything is predicated on making money for the company, the foreman told me I could take my time on this endeavor. Unfortunately, my slow and meticulous work pace didn't pay off and by the end of the first day on the project one of the two pieces I had worked on cracked before it was annealed and the other piece was considered unacceptable. In my eyes I felt that I had failed miserably, and there weren't enough words in the English language to convey my feelings of inadequacy.

I had never been so overly self-conscious and I left the factory worrying about being fired. Discouraged, on the way to the subway I decided to stop in at Saint Joseph's Catholic Church to meditate on the day and to pray for the strength and ability to complete the rest of the job successfully. For fifteen minutes I sat there asking God for the strength I needed to succeed at my job.

The next morning, Ralf, the foreman walked up to me and handed me some materials for a much easier assignment. I lost my cool but Ralf remained quite firm. I snapped at him, he responded, and we exchanged some increasingly heated words. Fritz, the senior glassblower who had been watching this exchange, quickly came over to my bench and told Ralf he would see to it that I completed the rest of the Saint Vincent's job correctly. Luckily, Ralf acquiesced, but then walked away in a huff of anger. I was left standing there, knowing I had to succeed.

Talking back to a factory foreman is never a good idea, and believe me it was not my finest hour, but I felt fortunate to have a

second chance. Working with glass was beginning to define me as a person and at this point "getting it right" was my only option. Fritz, who worked on the bench right behind me, was true to his word and gave me a few pointers on how to improve my material preparation and work. Along the way, he critiqued my work and rejected some of my components. Determined as I was to work through this dilemma, I immediately started to put in extra time by working through my lunch time and breaks. The shop steward saw what I was doing, however, and made me stop doing it. With the emotional and physical energy I was exerting and the support I got from Fritz, I completed the project in an acceptable and timely fashion. I would like to think that Ralf respected what I had accomplished, but he never said another word about the entire affair.

In due time my assignments became more difficult, the harder work indicating that I had acquired glassblowing skills and this progress was being recognized. However, to finish a task on time, occasionally I had to rely on a little help from my co-workers. I would ask an apprentice to add some extra components to my material preparation, which would give me a few extra pieces to cover up any mistakes I might make on a certain job. I never wanted quality control to reject my work, so if meeting their standards meant making a few extra pieces of whatever and having the failures disappear into the bucket, it was all right with me.

As I gained experience and confidence working with glass, I started thinking about becoming more creative within the glass trade and contemplated the commitment that this would entail. From Sloan House I could walk fifteen to twenty blocks in any direction in and around Manhattan, the perfect place to witness

the wide variety of artistic expression that only New York could offer. I also enjoyed living and being independent in the city, where every block had two or three restaurants and the subway system was always easily accessible. Of course, the greatest benefit of living in New York, relative to living in New Hampshire, was being closer to Pat, who I would visit almost every weekend. As a matter of fact, during one of my first visits back home after I moved to New York, we set our wedding date.

Residing at Sloan House was like living in a dorm without restrictions, and it was full of creative people who would gather in the cafeteria for group dinners. Most evenings we would sit around eating, drinking coffee, and arguing about race relations, communism, or some other current issue. But Wednesday nights were always special to me because we would have lectures on contemporary literature from either a guest speaker or a writer who was residing at or was connected with the YMCA. Nights at the Y became my social outings and my continuing education, and I thrived in this environment.

A few nights each month I would venture into Greenwich Village to hear folk music or poetry readings. I believe that one night I actually caught a then-unknown Bob Dylan performing in a coffee shop. Gradually, I found myself becoming intrigued with those people who were creatively expressing themselves, those artists who seemed so courageous and bold. I felt comfortable around them because they accepted me for who I was and I didn't feel the need to impress them. What I respected most, though, was how easily they adapted to self-imposed poverty as they continued on their journey of self-expression. I admired their spirit and accomplishments and loved the dynamic of non-conformity,

but theirs was a world I was not accustomed to. So most of the time when I was in the Village and among its people, I felt as if I were the proverbial outsider, the one always on the outside looking in. I found the Village to be a lonely place, made even worse by the absence of natural elements — the trees, flowers, and birds, all now missing from the landscape.

Soon I became friends with a co-worker, David Whittemore — a skilled glassblower and an interesting person to talk to — who, coincidently was Frank Whittemore's brother. David was actively making sculpture using soft glass, and it was difficult to believe that he had actually hauled large, heavy oxygen cylinders up five flights of stairs to his apartment where he created his pieces of art. When he talked of leaving scientific glassblowing for a more active life in Off-Broadway theater, I just couldn't relate to his giving up on a career that had taken him years to master. Years later, though, I was delighted to see his artwork documented in *Contemporary Glass*, a book by Susanne K. Frantz that was published in 1989.

Another one of my good friends was Ida McCray, a co-worker who had come to Fisher at a time when interest in ornamental glass was waning. Ida was the first female glassblower I had ever met and working in scientific glass was her way of subsidizing her studio work during this slow period. At the factory she expected and received equality as a black woman in a white man's world, and her highly skilled craftsmanship was respected throughout the glass department. In the early sixties she exemplified the spirit of a civil-rights pioneer.

In her mid-thirties, Ida was now leasing a small studio on Delancey Street in the Village, not far from where we worked.

Often after clocking out we would have coffee and a muffin before going to her studio where she gave me an informal creative internship. Since she had all the equipment necessary to make a variety of ornamental objects, she was able to teach me spun-glass techniques along with different methods of working solid glass rods into novelty items.

One of her more impressive objects was a spun-glass star-shaped cup, designed to fit over a small light bulb. The light from the bulb would emanate through the crystal star creating bursts of light that illuminated the ceilings and walls. I was quite impressed by the sparkling lights with their lampworked components, and for the first time ever I realized that lampworked glass could be used as interior design elements. Recently when I was in Philadelphia I saw this same design in an artist's studio, his funky-fabricated chandeliers reminded me of the sixties.

Eventually Ida and I lost touch with one another. When I returned to New York City years later I was unable to locate her, and I am sorry for that. Yet, each January when we celebrate Martin Luther King, Jr.'s birthday I think fondly of her and regret I didn't have the sense to accept her invitation to hear Dr. King speak at The Cooper Union, a respected center of arts and science education. It would have made a memorable story to tell my grandchildren.

In March of 1964, a few of us at Sloan House began talking about moving into an apartment. If we shared expenses we could live in a better and more comfortable facility, while saving money on food and rent. Three of us made the commitment to find a place on the Upper West Side, and although we were worried that landlords would discriminate against us because Jesse was

black, to our surprise it didn't happened. As it turned out, we ended up renting a third-floor brownstone studio apartment located on 87th Street, with a building superintendent who was in a mixed-race gay relationship. The apartment was suitable for our needs, and even though I would not be living there on weekends, I was more than eager to be involved in this new adventure.

Here was my first exposure to the Bohemian life-style, with its pulsating creative energy centered on several different genres of music and art. Most evenings, beginning around 8 P.M., our two Puerto Rican neighbors would practice their spicy Spanish music rather loudly with their xylophone and trumpet. Their apartment seemed to be a magnet for numerous friends with musical interests, and when three or four of them would play together an incredible melting pot of sounds would resonate throughout the building. An attractive art student on the second floor would keep her door open while she painted, so the hall almost always smelled of oil-based paints. Her art-student friends gave the entire complex an up-beat buzz and numerous other musicians would keep the nights lively. At times, sleep was hard to come by.

For the most part, pot was the drug of choice, and when the music started up, the smoke started to rise. There wasn't much fanfare when I declined to join in the fun. Nobody cared.

But then there was that Wednesday night during one of the usual jam sessions that the group began bragging about their terrific, really great, Spanish dope. As they were laughing and passing the joint around, the curious part of my nature took control, so I took my first hit. Immediately, I was cool, and throughout the rest of the night everyone made sure I stayed cool, so I just kept inhaling and laughing and laughing some more.

After getting back to my apartment quite late I immediately crashed, slept for about four hours, and then woke up disoriented, confused, and paranoid. Thinking I was going to be late for work, I rushed to the subway and boarded, but within a few minutes I started feeling claustrophobic and began to hallucinate. I sensed I was in the middle of a really bad nightmare and believed I was going insane. When I finally got to the factory I told Ralf the foreman that I was sick, then I left work, hailed a cab, and told the driver to take me directly to the Port Authority. Once there, I boarded a Greyhound bus for home.

When I arrived in Camden, New Jersey, I called Pat's father, Walt La Patrick, who I knew was between jobs and would be available to help me out. Around noon I walked into my parents' house, told my mother what I had done, and then told her I didn't feel well and wanted to go to bed. I slept for eighteen hours, waking only once when my mother woke me up to tell me that Pat had called to voice her concerns. The next morning I was still an anxious mess. I couldn't understand how this "harmless" drug could have been so dangerous, and even to this day I will never know if the Spanish dope was laced with LSD or contained heroin. I do know that this one encounter with drugs left a lasting imprint on my life. The fear of being intoxicated and losing control where insanity could be just below the surface has haunted me since the experience.

A few days later I took an early bus back to the city, checked into Sloan House, and never returned to my apartment. Focusing on work occupied my thoughts during the days, but when I was unable to sleep at night I would walk over to Times Square where I felt invisible but safe, I was having trouble shaking off

the pronounced anxiety that I had come to feel, partly — but not entirely — because of my bad experience with the Spanish dope. Despite the struggle, my determination to master my craft was proving to be stronger than my personal fears and insecurities.

After two-and-one-half years of dating, Pat and I were married on May 2, 1964. We had talked of living in New York City but decided against it, the Big Apple being just a little too big, too costly, and filled with too much energy to appeal to us as we entered a new stage in our lives.

The Dream of Being Creative

I returned to South Jersey when Pat and I were married and considered making glass on my own for a living. As I was preparing to set up a workbench in my father-in-law's garage, however, I realized that I didn't have a clue about starting a creative glass business, let alone supporting Pat and myself.

Instead, I continued to work within the scientific glassblowing industry, even though it was becoming more and more difficult to manage my inner need to be creative. I wanted to keep that creative spark alive and, since there was very little chance that I would ever receive any formal training in the arts, I decided to teach myself something about art. With that in mind, Pat and I started going on weekend excursions to craft fairs and galleries — and, as our family grew, our children joined us on our explorations. Before long we were attending assorted lectures and visiting museums. We also observed glassblowers making vases and creating antique paperweight reproductions. Increasingly,

these adventures became my window onto the world of studio craft, as each thought-provoking experience helped me to discover something unique and exciting about its diversity. We didn't fully realize it at the time, but we were witnessing the birth of what soon became the studio glass movement, the artistic process of working with hot glass outside of an industrial setting.

While the studio glass movement was progressing through its growing pains, it didn't take us long to learn of Harvey Littleton and the new breed of creative glass artists and craftspeople. Harvey Littleton was at this time a member of the University of Wisconsin art faculty. He had been a ceramic artist but, by the early sixties, had established a program in glass art in his department. The program was attracting students, the new frontier of art in glass was being explored, and people beyond the Wisconsin program were taking note of it.

About this time, my friend Jim Friant, a student at the Philadelphia College of Art, informed me that scientific glassblowers were no longer the keepers of the trade's secrets. Even though this surprised me at first, I was happy to hear that others were taking creative risks while learning glassblowing.

Throughout most of the sixties I relished my exposure to the new but small world of contemporary glass and other interesting crafts and continued to be fascinated with paperweights and their makers. I constantly dreamed of one day quitting industrial work to make a living on the creative side, but until that became possible, I had growing responsibilities and the bills had to be paid. I needed a steady job.

In 1964, the US Government was spending billions of dollars on research, which in turn generated major growth within the scientific glass industry. I like to think I caught the wave when

I returned to South Jersey and was immediately hired by Andrews Glass Company in Newfield. The pay was good, the work at first was interesting, and my skill level was up to par with most of the other glassblowers. Although at twenty-one years of age I was the youngest glassblower working at Andrews, I wanted my foreman to know I was energetic and determined to get each task done correctly. What he didn't know was that I had brought with me my underlying fear of failure, and as hard as it is to believe, this fear kept me focused.

Andrews produced different types of apparatus for scientific glass distributors, which meant that work orders were usually quite large. For the first time in my career I would be making the same object for seven to fifteen days in a row. For me, the biggest advantage was getting to learn some very complex glass fabrication techniques, but the downside was that these repetitive jobs often would become quite boring.

Without windows or air conditioning, the work environment at Andrews in the summer was hotter than a humid South Jersey heat wave. In the winter, on the coldest Mondays, we would arrive at work to find the water containers on the bench crusted with ice. All year long, especially in the mornings, we had to cope with air pollution that was seeping into our building from Shieldalloy Metallurgical Corporation, located across the street. This huge foundry would pump pollutants into the air, and when the wind blew in our direction, not only could we smell the contaminates, we could actually see them sparkling in the flames of our torches. Some of us tried wrapping bandanas over our noses and mouths, but there were days when nothing could protect us from inhaling the murkiest, dirtiest air I have ever breathed in my life.

In the South Jersey area, production glassblowers were becoming concerned that graduates from Salem Technical Institute's scientific glassblowing program would flood the market. Consequently, they worried about their wages being lowered or the possibility of losing their jobs. That helped explain why most of the other glassblowers at Andrews would periodically visit my bench to check out my work when I first started working there. I guess they were afraid that tech school graduates like me held trade secrets that would advance our careers while putting them in the unemployment line. Although I felt they didn't have to worry about me, a blue-collar worker like themselves, in truth, the students at Salem were being trained to better serve science and the glass industry.

Eventually we glassblowers all got along, as I adapted to their fast paced work ethic, the fiery heated political debates, and their constant streams of vulgarities. Today, I can't help but smile when I conjure up this time in my life when I was the ideal Whitmanesque newly married young man, happy to be working five days a week and carrying a lunch kettle packed by my wife. At the same time, I was a skilled laborer who was working very hard in a typical non-union American factory.

Be that as it may, with my earnings and Pat's savings we were able to get a mortgage on a house that cost $4,500, a handyman's special. Situated on a beautiful wooded lot in Mantua, this unique house had its living quarters on the second floor because the previous owner had housed his machine shop on the main level. With its metal-framed windows and cement floors, it looked industrial. It was the ideal space where I could set up a lampworking bench and other equipment, which was a good thing, as Andrews Glass had just offered me a home workers' license

to fabricate glass atomizers. This meant I could earn an extra fifty dollars a week lampworking at home, and within a few weeks I was making six to eight dollars an hour. Unfortunately, what should have been a sweet deal soon turned out to be monotonous drudgery. Boredom led to procrastination and then I started hating the work at home altogether. I was relieved when the overtime ended six months later, even if it meant that Pat and I were going from feast back to watching every dime. Fortunately, however, I did now have workspace at home and soon would put it to a different use.

Around this time Pat suffered a miscarriage, and as a couple, our eyes were finally opened to the tragedies and mysteries of life. But within a year Pat was pregnant again and she decided to quit work so she could stay home and focus on having a family. For now, everything seemed to be going well and I thoroughly enjoyed coming home from the factory to a home-cooked meal.

Once during these intervening months my friend from the Macalaster Scientific days, Rick Ayotte, drove down to see us after attending the 1964 New York World's Fair. We spent some of the evening talking about the glassblowing demonstrations at the Fair, of the glass novelties being sold there, and about our good times in New Hampshire, but gradually our conversation centered on how much I wanted to make contemporary paperweights and how both of us genuinely believed in the future of creative glass. It was nice seeing Rick again and it was great to know we were still dreaming of one day making our mark in glass art. Today, when I look back on our forty-year friendship, I realize the glue that bound us together for all these years has been our common interests, our love of lampworking, and our respect for the natural environment.

&

In June of 1965, *Woman's Day* published an informative article on contemporary and antique paperweights. This colorful exposé gave glass collectors their first exposure to a wide variety of paperweights and introduced thousands of others to the practice and pleasure of paperweight collecting. Not surprisingly, the marketplace responded as dealers and new collectors became enchanted with these decorative glass objects. I was flattered when friends and family members offered to give me their copies of the magazine, because it meant they knew just how much I wanted to become a paperweight maker — and it meant I had more copies to save and treasure.

At the factory, I had now progressed to making gas chromatographic columns and was bending coils for a new generation of mass spectrometers. In other words, I was working hard and mass producing instruments from capillary tubing. One day, Frank Whittemore, who was touring the factory as a buyer, recognized me from my days at Salem and stopped at my bench to say hello. I told him that I had worked with his brother David in New York City and then complimented him on his paperweights which I had seen at Glick's Antique Shop in Clayton, New Jersey. However, I couldn't help griping about the boredom of my repetitious production work, whereupon he smiled and said, "That's how you get good, mister." It's interesting that now, when I look back some forty years later, I realize how right Frank was.

My career goal of working in a university science lab or corporate research setting was in direct conflict with my inner need to be a creative glass artist. Before long, I began to question if this tension was perhaps the reason why I was having some

problems with anxiety, both at work and at home. The one thing I knew for sure was that I was not going to end up like my father who dealt with anxiety by medicating himself with alcohol. In hopes of relieving some of my stress, and to make a few extra dollars, I began making glass animals in my home studio, eventually finding this to be a pleasant and cathartic diversion as I mastered the skills necessary to make ornamental glass.

Around this same time I needed to find a way of making some extra money, so I decided to ask an acquaintance, Tom Messina, owner of Messina's Cut Glass Factory and Retail Outlet located in Hammonton, New Jersey, if I could make some giftware to sell at his shop. Without skipping a beat Tom suggested I begin making miniature glass bottles with pennies in them because the factory-made ones had been incredibly popular and Tom had been unable to keep them in stock. Seeing that I would be able to work at home, hone my lampworking skills to work soft glass, and earn some extra cash, I thought the idea sounded like an interesting challenge. After thinking on the matter for a couple of days I decided to give the pennies-in-a-bottle a try.

First I had to locate an old-fashioned cross-fire torch, the type of equipment used during the thirties and forties — and then I had to learn how to use it. These torches were very efficient because they utilized natural gas and air instead of the more costly bottled oxygen, and using gas and air facilitated the ease of my working the soft-glass tubing. The real trick was figuring out how to trap each penny inside the tube without tarnishing the coin. I enjoyed teaching myself to lampwork soda-lime glass, which had different properties and was easier to work than the borosilicate glass I had been using in the industrial setting. And

lastly, with the help of a machinist, I developed a new tool that would increase my production rate.

Those technical problems solved, within a month I was selling my bottles and soon would be making up to twenty bottles an hour. At thirty-five cents each, I was in the money! Subsequently, Tom began talking about wholesaling my penny bottles to tourist attractions across the country, and thinking it a great idea, I began fabricating them as fast as I could, like a robot. Unfortunately, maintaining a relentless pace at work and at home began to take its toll, and before long I was physically and mentally exhausted.

To this day I am unable to recall the exact circumstances surrounding the evening in question, but on one particular night I couldn't stop my thoughts from racing out of control. Within the dim light as I lay in bed, all I could see were oddly shaped floating bottles and distorted scientific glassware, all I could feel was incredible fear and frightening panic, all I could think about was fear of going insane, and all I knew was that I was scared to death. What was happening to me was the result of three or four years of intensifying discomfort from anxiety.

Although I wasn't a psychiatrist, even I could figure out that the repetition of production glassblowing and my novelty glass bottle-making had finally stressed me to near the breaking point. So, for my sanity's sake I decided to blame the episode on my long hours of working at home because I couldn't bear the thought that working with glass could actually make me physically or mentally ill.

After coming to terms with this incident I quit working at home altogether and began praying more earnestly to my patron saint,

Saint Joseph, and had several chats with Father Kernan, our parish priest. To repay him for his kindness before I completely shut down my torch, I made him a very special glass crucifix.

My mental outlook improved slowly, but Pat and my mother would occasionally make comments about my cursing which was getting more offensive. Also, my outward appearance and jovial demeanor were changing for the worse. On top of that I was feeling intense anxiety Sunday nights just thinking about going back to production work on Mondays. Yet, in spite of everything, when all else seemed to be falling in around me, I could always dream of making paperweights. And throughout, Pat's love and patience, especially her willingness to listen, became the stabilizing factor in my healing.

It was apparent that I needed to find a more interesting and intellectually stimulating job, but I couldn't seem to get an interview at a research center in the Philadelphia area. However, hearing of an ad in the *Vineland Times Journal* for a skilled glassblower in Alexandria, Virginia, I wondered if perhaps a new job in a different area would improve the quality of our lives, ease my anxiety, and get me closer to the ideal research job — the one I thought I should have.

Patricia Christine, our first child, was born in December of 1965 and, as a result of wanting the best for our small family, Pat and I decided to drive to Alexandria to see what S & J Industries had to offer. We arrived over an hour late for my interview because I had driven around the Washington Beltway twice. Once I had demonstrated my skills to the factory's manager, everything seemed to be all right, which it was, since a week later S & J offered me a job as a first-class scientific glassblower.

After giving the matter a lot of thought, Pat and I agreed that I probably needed a change in surroundings in order to advance my career, so we decided to make the move to Virginia. Our resolve surprised our parents when we announced our plans. We sold our house, but kept the extra acre we had purchased a year earlier, and found a nice apartment to rent in Alexandria. The view of the skyline from our balcony was terrific and we had easy access to the Washington Mall where we visited the numerous and varied museums.

As far as work went, I think I tried too hard to convince myself that this job was the one that was going to inspire me to greatness. In truth, working here was far from interesting and the only thing I really discovered about myself was how much I detested repairing broken laboratory glassware, particularly after the pieces had been contaminated with toxic chemicals. Although Pat kept encouraging me, in the back of my mind I couldn't help but believe I had made a disastrous error in judgment by moving from New Jersey to Virginia.

After just six months at S & J Industries, Pat's mother called to tell us that Philco-Ford was advertising for a precision glassblower within their electron-optical division. The work sounded high-tech, the benefits looked good, and we wanted to be closer to our families again, so I applied for the job. It was about a three-and-one-half-hour drive to the interview, but on my way to Spring City, Pennsylvania, I began feeling really anxious and somewhat panic-stricken. My queasiness only increased when I arrived at the plant to discover it guarded and under heightened security.

Yet, as I approached the front door, I saw Frank Whittemore coming out of the building holding a cup of tea. We were surprised

to see each other, and as it turned out he was now in charge of Philco's glass shop. What a coincidence that the one person I had always admired was going to be evaluating my skill level. Frank, however, didn't bother; he said I was skilled enough and, without being tested, I was hired to begin work in mid-January, 1967.

As soon as we moved to our new apartment in Pennsylvania, once again my restlessness and anxiety surfaced. With the arrival of Pauline Marie, our second daughter, in 1967, the family was getting larger and more joyous. It would, however, be years before I understood why I would run from job to job with my pattern of doing something, doing it well, and then crashing.

That same year I went to one of the most exciting and thought-provoking exhibits I had ever experienced to date. It was being held at the Philadelphia Art Alliance, on Rittenhouse Square. On display was a collection of glass sculpture that had been created by German artist Erwin Eisch. Seeing Eisch's blown glass totems with their bulbous forms protruding out of cylinders was thrilling and I, like other art enthusiasts, applauded the non-representational forms he had produced. Eisch had studied painting and sculpture at the Academy of Fine Arts in Munich, Germany, and now he was making asymmetric sculptural vessels at the end of a blow pipe. Harvey Littleton — the glass-art visionary, art educator, and pioneer in studio glass — had discovered Eisch's work while traveling through Europe and invited him to visit the US to demonstrate and share his philosophy of art-making in glass with the Wisconsin students.

It was truly inspirational to see Eisch's works in a serious art venue, and I left the exhibit feeling optimistic, excited, and more determined than ever to dedicate my energy to making glass

art full time. After seeing this exhibit, I knew that I belonged on the creative side.

Pat also helped to nurture and reinforce my desire to become a glass artist by giving me three books about paperweights that would first guide me, and then change my future. For hours on end I would study the pictures, ponder over each image that captivated my imagination, and, in no particular order, read and re-read certain passages or paragraphs that were of interest. The books were John Burton's *Glass: Philosophy and Method*, Jean S. Melvin's *American Glass Paperweights and Their Makers*, and Paul Hollister, Jr.'s *The Encyclopedia of Glass Paperweights*. These books brought me closer and closer to my hoped-for future.

Mostly, because of my love for native flowers and the natural environment, I focused in these books on works by Charles Kaziun and Frank Whittemore, whose lampworked paperweights fascinated me. Their works encompassed more floral motifs as opposed to the French paperweights, which seemed to be oriented towards "millefiori" designs — those in which bundles of different colored glass rods had been arranged, drawn, and sectioned so as to make multicolored geometric or floral patterns. I found Hollister's book to be the most interesting because it compared the beauty of different efforts within the paperweight world.

Around the same time, I saw a Public Television series that featured glass-maker John Burton, whose celebration of creative lampworking solidified my resolve to become a studio artist. I knew I had what it would take to become a successful paperweight maker. My quest became my obsession, which compelled me to work long hours in order to learn the techniques that had been lost or, for years, had been closely guarded trade secrets.

Beginning in the Utility Room

In June of 1969, Pat, I, and our daughters moved back to Mantua, New Jersey, into a newly built house. We were so proud of our children, and with our newborn Katherine Mary, we were comfortable in our new space near family and friends. A small utility room served as my new studio, a space in which to work and earn extra money. Yet, my creative endeavors would have to wait for evenings since I was still working at Philco-Ford. Moving into the new home meant I now had over a one-hundred-mile round-trip commute to Pottstown, Pennsylvania.

My first task in our new house was to build a bench and set up my equipment. This wasn't too difficult because I owned only a few hand tools and a used National hand torch which I had purchased for ten dollars. Within a week I was experimenting with lampworking techniques to design small glass animals that would be sold as giftware items. It took me another six weeks to

develop eight successful models, with the glass elephant, the cat, and then the owl becoming the most popular pieces.

As we were moving into our new house, I noticed something on the ground that appeared to be a tarnished old medal. I thought it rather peculiar to find a medal there because just six months ago the land on which I was standing had been a fully wooded area. I became intrigued and took the object into the utility room and started cleaning it, only to be surprised to find that I was holding a crucifix from a Catholic rosary. Years earlier, I had heard stories of an Irish-American family with ten children who had lived in a shack on this property during the Great Depression, and I wondered if perhaps this religious symbol had once belonged to that family.

With the medal scrubbed and polished, and just before I lit my torch, I ceremoniously pinned the crucifix on the wall in front of my bench. I then asked God to bless my efforts, to give me his grace to make beautiful objects, and to enable me to work on my own. Today — as I have done for over thirty-seven years, sometimes as early as 4:30 A.M. — before I light my torch, I meditate, touch my medal and a mezuzah given to me by a friend, and say a daily prayer.

The first six months that we were in our new house, I worked my butt off nights and weekends making small figurines, most of which I sold for thirty-five cents each. By the end of that Christmas season, I had made about three hundred dollars to show for my efforts — serious money, but not enough to give me hope that I could support my family by doing this work full time. Plus, within a short period of time I was again getting bored with this home-production work.

From the beginning of my work in glass, I had wanted to craft paperweights, and now with this facility and a few tools to make them, the opportunity seemed right to turn my daydreaming into a reality. Pat and I began discussing the possibility of living through a couple of very lean years so I could buy more equipment and materials. In the end, it would be Pat's emotional support which enabled me to pursue my goal that kept us going. For two years, Pat would budget our income in order to support our growing family. With our now three small children there would be trips to the laundromat two to three times a week because I couldn't afford to buy a washing machine. Since both of us sensed the sacrifice was worth it, we learned to do with less, and debt became our constant companion.

Because there was no information available on how to make lampworked paperweights, my first six months at the torch were spent experimenting with the process — and thank God, I enjoyed success in my trials and errors. Soon I was sculpting small soda-lime glass animals that would be encased in clear glass, with each attempt taking about three nights to complete. I loved being emotionally engaged in every step of the process, and when an interesting paperweight came out of the oven I would remain on a creative high for hours. For the first time in years I was alive with hope.

Around this time I quit my job at Philco-Ford and started working at Rohm & Haas's research facilities, which was a shorter commute. My new job required that I travel regularly to three research locations in and around Philadelphia. One of the extraordinary benefits of this traveling was my being able to "borrow" the equipment that I was taking to these research locations.

I could not have afforded a Carlisle bench burner or the other Rohm & Haas tools that, because of this opportunity, I was able to set up and use at home a few week nights or on weekends.

Before long I began to believe that if Frank Whittemore, Charles Kaziun, Ronald Hansen, and Paul Ysart could be successful, independent paperweight makers then I could be one too. Since I loved nature and had been fascinated with wildflowers as a child, my next logical progression was to lampwork glass flowers that could be encased in crystal. However, the process of the encapsulation of flowers successfully in glass was the greatest challenge that I had faced up to that time. Actually it was much more challenging than working in scientific glass. With perseverance, one of my strong positive attributes, I began to master the necessary techniques and soon discovered the personal rewards of experimenting with new ideas and simple designs. In a very magical way it seemed as if each paperweight design was waiting for me to discover its creation, then its beauty.

My first piece sold for ten dollars, but it would be close to a year before I thought my work was worthy to show Arthur Gorham, a respected paperweight dealer. When the time felt right, Pat and I headed for Millville, New Jersey, in our old Volkswagen "Beetle," with our three little girls bouncing in the back seat the entire way. I brought three of my most successful paperweights to offer to Mr. Gorham. To my delight, he purchased my three weights for twenty-five dollars, and included a membership in the Paperweight Collectors Association (PCA). These were my first signed paperweights and their sale represented a beautiful milestone

for me, as it meant I was slowly but surely getting it right. Little did I know what my commitment to paperweights would entail and how this new endeavor would forever change, and thereafter define, my life.

My three years of part-time paperweight-making became an exercise in perseverance. Each day, whether I failed or succeeded, I was proud of the progress I was making in my small utility room. I soon realized what had been lacking within myself all of these years of working in glass. I needed a means of self expression. Further, and what fascinated me the most, was discovering I had an internal drive that was turning out to be an undeniable source of creative energy. Yet, my artistic journey would prove to be "a long overcoming."

One of the first creative decisions I made was to not use millefiori canes or any other mass-produced decorative components in my work because I wanted to develop my own creative point of view. It would be my skilled hands, with the help of a few simple tools, which would create the botanical portraits I had envisioned. With my work ethic as a foundation and my years at the torch, which had allowed me to develop the necessary lampworking skills, I was able to nurture my personal vision based on discovery.

I enjoyed discovering new techniques and experimenting with oxides. One of my most important creative decisions was to invent a fresh illusion, or breakthrough, for each new design. I wanted each paperweight to advance both my art and knowledge. For me, the criteria for a breakthrough was to create a distinguishing illusion or result that was unlike the nineteenth-century French paperweights or other contemporary works. One

of my most satisfying advances was the creation of the earthen root systems that cling to the flowering plants in my work. This visual idea led, many years later, to more ambitious botanical portraits that allowed me to contrast myth associated with the unseen world under the earth to the flowers growing above the earth.

I also wanted to focus on designs with interesting colors, so before long I began experimenting with different shades of color, some of which served as backgrounds for my first paperweights. Occasionally, I would push the boundaries of what I considered good taste and the resulting flowers would clash with the flashy backgrounds, even though it seemed that the marketplace was responding to intensely bright background colors, which I felt detracted from my delicate glass flowers. I followed my instincts and stopped worrying about what would sell, and started making work that pleased my artistic sensibilities. After many attempts at combining colors, I followed my natural preference for pastels. Interestingly, this preference for certain colors is still apparent in my work today.

I spent a great deal of time and energy learning how to make a black and white glass signature cane before I made my first paperweights. For the first time in ten years of working with glass, I would be able to acknowledge my own work, so it was with great satisfaction and pride that I began to sign each paperweight with a PS or S glass cane that was either melted under a flower or sealed into the side of the glass. The signature canes represented to me an end to the years of anonymous production glassblowing and the beginning of creative ownership of my artwork, and I consider its appearance to be a turning point in my journey.

Making paperweights meant that I had to differentiate between what constituted good work and which pieces needed to be rejected and crushed in the bottom of my cullet bucket. Common failures occurred when the lampworked flower or other elements lost their standard of quality or, as I like to say, integrity. The breakdown of a color — the development of an unintended shade — which reduced attractiveness was another reason that a paperweight could be rejected. However, the most common reasons for rejection were that an air bubble had been trapped inside the encasement or a lampworked part had become detached. Although they were often seen as part of the floral motif by those who collected antique American or French paperweights, I saw these air bubbles as visual distractions. With my evolving standards I wanted to minimize air bubbles or, "dew drops," as they were sometimes called. For what seemed like ages I was trapping a lot of air, and about twenty percent of the time I was able to save the paperweight by pulling the glass away with my tweezers and then dragging the bubble out. It would take time to get more proficient, and it would take me years to conquer some of my other technical problems, yet for some reason I have never had trouble dealing with lost labor. After all, from the beginning I had committed my labor as a prayer to "getting things right" and making interesting objects that visually speak of quality. I was not going to make compromises. I had set high craft standards which would be necessary if I was going to achieve my personal best and distinguish my work from others — and get myself out of the factory.

Today, when up-and-coming glass people ask me questions, I suggest they too try figuring out their own technical problems.

Sometimes this suggestion comes across as if I am being secretive or harboring some deep mystical answer, which is far from the truth. It has been my experience over the years that successful artists have invented their own techniques and processes to create work that is personal and original to them. Trial and error is the only way that I know, to discover a personal vision and create new ideas for making unique work. In addition, I can't stress enough that if glass artists really want to learn their craft, they can examine the history of glass through the numerous objects at the Corning Museum of Glass or they can spend one or two days in its library, where thousands of documents, videos, and books are waiting to be explored. The main way that I learn is to sit at the bench and be attentive while working the hot glass, but again, if there are any secrets out there, I am not aware of them.

By the summer of 1971, my success rate was about five to eight good paperweights a month, and on occasion, dealers would call me and ask for my work. Each one of my pieces retailed from fifty to one hundred dollars and from what I was hearing they were generating enthusiasm among collectors. It seemed as if my hard work might finally pay off, and more good fortune was about to follow after Pat, my new business manager, was happy to tell me that I had actually made enough money to cover the expenses of my part-time job. If that news wasn't exciting enough, Pat told me a woman had just called to say she wanted to drive all the way down from Connecticut just to look at my work.

Mrs. Hartunian, a distinguished looking woman, and her son Al arrived shortly thereafter on a Sunday afternoon. After

having a very pleasant conversation about glass paperweights with this astute collector, she commented on how my paperweights appeared to be different from other contemporary weights. Her compliments were a source of great joy, especially when she asked me to help her choose three pieces. After the selection was made she paid me two hundred dollars, which represented a major purchase, and believe me, they were barely out the door before Pat and I checked and then re-checked the money. Within minutes we were out of the house ready to celebrate big time by taking the kids to the ice cream parlor!

In 2004, after having given a lecture titled "Floral Paperweights in the Round" to the New England Chapter of the PCA, a pleasant looking gentleman came over and introduced himself to me. Albert Hartunian then reminded me of his visit to our home when he was much, much younger. Now here he was, jogging a precious memory and purchasing one of my new orb bouquets that would balance out the collection he inherited, one that his mother had started almost thirty-three years earlier. It was a very special experience.

Throughout my glass journey the collectors I've had the pleasure of meeting have made my career a joy in ways that I could never have anticipated.

In the beginning there were times, because of my excitement and lack of patience, when the hardest part of the entire paperweight-making process was waiting for the annealing oven to cool down so that I could see what I believed would be a masterpiece. I knew my temptation to open the oven door and view

my work could become technical suicide for the glass being annealed. I realized I had a problem with impatience when, one time, I opened the oven door prematurely to view a paperweight while the glass was cooling. What would have been a masterpiece cracked before my eyes. That evidence of compulsion made me realize how obsessive and emotionally involved I had become with making paperweights. I told Pat about this problem because I worried that my behavior might indicate mental illness. I found that by identifying this problem and talking about it with Pat, I believed it wouldn't happen again.

Even through Rohm & Haas had afforded me the ideal research job, a goal that I had set at the beginning of my training, I was still unhappy at work. While working in scientific glass, I would find myself dreaming about glass flowers and would occasionally sneak time to make some. In 1971, the summer of my discontent, I began shutting down.

I had become too emotionally involved with my paperweights and became physically exhausted, unable to keep up my pace. I found myself in a cycle of eating junk food, sleeping on the couch after work, and then eating and sleeping some more to cope with my anxieties. Also during this time I had to contend with the worst case of hives my doctor had ever seen. When he told me to slow down, I decided to quit working evenings. Consequently, for the next three months I watched a lot of television, did a little landscaping around the house, talked with Pat about my worries and fears, and prayed.

After a while, my mental state began to improve and soon I was feeling a lot better, becoming revitalized and stronger than ever. Although my body would tell me when I was over doing it, by presenting me with a periodic return of the hives, I just had to

get back to the utility room and my paperweight-making. With this return, I finally broke the cycle of crashing, quitting, and moving on. Looking back, this return to the work I loved was a major breakthrough in my growing ability to manage my emotions.

I was joyful and thanked God to be back at my torch. My success rate slowly improved as my work went out to a wider circle of collectors. Increasingly, I believed that making paperweights could be my ticket out of industry, and to be able to make a living on my own that would be sufficient to support my family. I knew I had to work at what I loved, wanted, and needed to do.

Wishing to test my resolve, I decided to respond to an ad in the *Antiques Trader* magazine, one in which Larry Selman, a dealer, was advertising his interest in buying and selling paperweights. I thought this would be a great opportunity to get my paperweights out in the market, so with a sense of urgency I wrote him about my work. When I didn't receive a reply soon enough to suit my impatience, I phoned him at 9 A.M., which unfortunately wasn't very smart of me since Larry lived in California. When he answered the phone at what was for him 6:00 A.M., it would be an understatement to say that I was somewhat embarrassed.

My impatience not withstanding, Larry and I developed a good working relationship and within a few months I received one of his modest early catalogues in the mail. There among the contemporary and antique paperweights were images of my work. This was the first time that images of my pieces had been reproduced in print, and as I turned the pages of the pamphlet I knew everything would eventually be all right.

The Patron Saint
of a Struggling Artist

During the mid-sixties Pat and I would go back to Wenonah, New Jersey, to visit our parents. In my spare time I built Walt La Patrick a glassblowing bench in his garage, using much of his welding equipment. In due time, Walt became quite skilled at his new hobby, lampworking. Before long, Walt began selling glass animals to his friends and soon he and his wife, Ann, started following the craft-fair circuit. In 1971, they were accepted into the Indian Summer Art and Craft Show, which was held each September in Atlantic City, a place where thousands of people would come every year to stroll along the boardwalk, admire the artwork, and hopefully buy some of it.

Because Pat's parents had offered to display my floral paperweights alongside their large menagerie of glass animals, we drove over to Atlantic City to enjoy the art fair and to have a little bit of fun in the sun. That Saturday afternoon, while I was playing on the beach with my three little girls, Walt was having an

interesting chat with the head judge of the art fair. Later, I learned that Walt had been talking with Reese Palley, who, after looking at my paperweights had declared, "This is the real stuff! I want to meet your son-in-law in my gallery, and soon!" Little did I know then how that chance encounter would affect the rest of my life.

In short time, I was in Palley's gallery introducing myself to him, all the while having no clue about this odd character's reputation within the art world. After a brief conversation, Palley invited me to bring fifteen paperweights to an open house he was hosting in December. I told him it would be too difficult to have that many available, so he simply smiled and invited me to look around his gallery.

A few weeks after meeting with him I was talking about paperweights with Dr. Tom Stewart, a chemist who stopped in the glass shop at Rohm & Haas where I was still employed. During our conversation, I told Tom of my Atlantic City adventure and that I had impressed some gallery owner, whose offer I had declined. Tom laughed at my story and then told me that I had turned down one of the most successful and well-respected art dealers in the country. In fact, Tom added, in the current issue of *Philadelphia Magazine* there was an article about Palley, and yes, he was an extraordinary dealer of objects d'art.

The next morning Tom brought me a copy of the magazine with Reese Palley on its cover. A Boehm porcelain bird was perched on his head and the caption read *MERCHANT TO THE RICH*. The ensuing article focused on how phenomenally successful Palley had been in bringing high-end art objects and collectors together within the American porcelain market, and then

it went on to describe Palley as being a flamboyant genius, a man who dressed in black and enjoyed driving around Atlantic City in his Rolls Royce. So here was Reese Palley, attracting national attention for his art marketing success, while I stood there dumbfounded, my stomach in knots, kicking myself for a lost opportunity.

It took me a couple of minutes to collect my thoughts, and the next thing I knew I was calling Palley's gallery, only to find him unavailable. Yet, his assistant, Mike Pred, listened to my story and when I told him I could get fifteen paperweights to them by the time of the show, he put me on hold, was gone for a few seconds, came back to the phone and said, "Welcome to the Reese Palley Gallery. We need your paperweights here one week before the opening."

On a cool Saturday in December, I found myself in the company of over one thousand people who were attending Palley's open house, which was being held in his gallery, a large beautiful space situated on the Atlantic City boardwalk in front of the Marlborough Blenheim Hotel. Interestingly, this hotel was the first structure to be built with cast concrete — a process invented, and the hotel's work supervised, by Thomas Edison. In grand style, Palley was treating all of his guests to a free weekend in the city, while at the same time providing a festive atmosphere where up-scale art collectors could schmooze with one another. As always, he was the center of attention, a fact noted by the press covering the gala event for its Sunday papers.

But I am getting ahead of myself. At his Friday night reception, I had sold eight paperweights, and with that success Palley had started asking me questions about my glass-making process so he could better discuss my art with his favorite clients. The

strategy must have worked because by mid-day Saturday, I had sold another five paperweights, each ranging in price from $110.00 to $135.00.

With positive feedback coming from both knowledgeable and novice collectors, at some point that afternoon Palley turned to me and said, "Paul Joseph Stankard, you should be doing limited editions of your paperweights." He then became animated, emphasizing that each paperweight would have to be outstanding with each piece crafted to be "only top rate stuff." My response was an immediate "Let's do it," and after a few moments of reflection, Palley suggested that the first limited series be titled, "The American Floral Series."

With unusual fanfare Palley then directed his assistant to place a sign-up sheet next to my work so that collectors could order from this series, which in the end would encompass ten designs. Unbelievably, by Sunday afternoon over 250 paperweights, at $150.00 each, had been ordered. The instant success made me feel a little self-conscious, and in short time, I started getting anxious about having to make so many flawless paperweights. Plus, I had to confess to Palley that it was going to take years to fulfill my obligations because I was still working full time to support my family and was only making paperweights part time in our small utility room. To my tale of woe Palley simply replied, "Stankard, you should be making paperweights full time, and if you continue to do significant work, you'll be all right, and I'll guarantee it."

Two weeks after our fourth child and first son, Joseph Paul, was born, I quit working at Rohm & Haas, where upon Reese became my new and tough mentor. He was constantly stressing

the importance of quality and integrity, two ideals that began to shape my work. His love of art objects, including the skilled virtuosity that respected and built upon the past, inspired me to look more closely at the decorative arts tradition within the context of excellent design and workmanship.

When he saw the modest native flower guide that I was using to develop designs for my weights, he suggested that an actual botanical book, one that would help me experience nature though the eyes of other artists, might be more useful. I told him this was an excellent idea and — lo and behold! — within minutes Reese was on the phone to a New Jersey book dealer who was then given a $250.00 budget to select a collection of books that had detailed floral illustrations. Within days I received twelve books, four of which were printed in the 1800s, all featuring beautifully rendered colored and hand-worked botanical illustrations. This incredible gift not only provided me with sweet, close up visual experiences, but the books turned out to be tremendously inspirational. For years they have brought me much joy, and many of my evening hours have been spent looking at the flowers and dreaming how to sculpt glass into organic illusions.

As my first art teacher and mentor, Reese Palley celebrated and emotionally supported my efforts to translate nature's plant kingdom into glass. Each glass component fascinated him, from the divided stamen, to the veins, to the natural green sepals. For every new idea that I developed, he would recommend further experimentation. The way I layered the colored glass to suggest dimensional illusion excited him and he thoroughly enjoyed being "up-close and personal" with the creative process. Occasionally, he would suggest a name for a new technique, what I called

an illusion, such as the compound paperweight technique that resulted in a new series.

Once, when I asked Reese if he believed me to be an artist or a craftsperson, he looked at me sternly and said, "Never let all that bullshit distract you. Just continue to make great work."

Unquestionably, it was Reese who nurtured my early style, and sometimes when people ask me about my educational background, I light-heartedly tell them I received my degree from the Reese Palley University. My business relationship with Reese continued until the casinos came to Atlantic City, at which time Reese sold his real estate interests in the city and retired.

A few years ago, after reading in the news that Reese would be speaking at the Philadelphia Maritime Museum about his round-the-world sailing voyage, I decided I had to go hear him and say "Hello." His lecture, which had kept the audience spell bound, turned out to be quite informative, and after he answered some related questions I walked over and greeted my old friend by exclaiming, "Saint Palley, the patron saint of Stankard Studio!" With his typical laugh, Reese, who at seventy-eight and in excellent health, raised his hands and replied, "Everybody should be a saint to somebody." It was great seeing Reese again and it wasn't long before memory transported me back to that very serendipitous September afternoon so many years before.

Learning about Kitsch

I had been crafting paperweights for a little over two years when I was invited to show three of my pieces at the New Jersey State Museum. The exhibit's title referenced "South Jersey glass" and included a selection of eighteenth-, nineteenth-, and twenti-eth-century blown and pressed glass, along with a selection of early to contemporary paperweights. Needless to say, I was thrilled to have my glass in the same company with that of the highly prized Millville Rose — an innovative paperweight process and design developed in South Jersey that resulted in a glass rose suspended in the center of the piece. As a whole, the display highlighted artistic and technical diversity with special attention to paperweight-making. Being one of the featured artists made me realize just how much I wanted to succeed. I even found myself wondering if someday my paperweights might be included within a historical continuum.

All and all, this first public exhibit of my work was an educational and enlightening experience, and I must admit I was greatly encouraged after receiving a few positive responses from collectors who had attended the show. Of course, I was the only one who knew that it had taken two years with many failures to produce those three pieces worthy of being displayed.

My main focus of perfecting old and creating new paperweight-making techniques was reinforced. Yet, I was becoming aware of a negative bias in the glass-art world towards paperweights and the lampworking process. In 1970, Pat and I had gone to the Philadelphia Civic Center Museum to see a contemporary craft exhibit. Its focus was to present crafts as fine art. The opening day lecture was presented by Helen Drutt, a craft-gallery pioneer, educator, and nationally respected collector and craft critic. I was fascinated by her overview of the emerging contemporary glass movement and enjoyed hearing what she had to say about Harvey Littleton and Littleton's friend, glass technologist and inventor Dominick Labino. One of the most interesting aspects of her lecture was that she identified Littleton as a glass guru and explained how he had succeeded at promoting working in glass to other artists such as Dale Chihuly, Dan Dailey, Marvin Lipofsky, and Richard Marquis. As the seventies unfolded, an ever-increasing number of artists would be added to this list.

I was surprised to hear the audience chuckle when Ms. Drutt, in what I thought was an elitist manner, categorized paperweights as being "kitsch." Thinking paperweights needed to be defended, and tempted right then and there to challenge her about the validity of contemporary paperweights, I decided instead to keep my mouth shut and learn about kitsch. I was curious about, and was beginning to solidify my own perspective

concerning, the art-vs.-craft debate, and kitsch was a new dimension in the discussion.

Over time, I came to understand that there would be some who would view my art as being too crafty, and yes, just a little bit too kitschy. To many elite critics and collectors in the art community, floral art was often considered boring or too sentimental. Moreover, after taking the time to study the history of floral art and seeing an exhibition at The Academy of Natural Sciences in Philadelphia, I could see how these art enthusiasts formed their opinions. The floral paperweight "kitsch" of that day was, compared to my work, more about bright and gaudy combinations of colors that looked very artificial. To me kitsch isn't necessarily a bad thing, as it usually revolves around folksy commercial craft or sentimental objects, but it was my dream to become successful in an art context. I knew my work would have to go beyond glass trinkets, giftware, or the mundane, and I was developing a Zen-like expectation for the quality of my work that would protect its integrity.

From the beginning of my creative journey I wanted my glass art to evidence excellence in craftsmanship, within the context of an ongoing decorative art tradition. To further that goal, I believed that by developing new techniques I would be better able to interpret the life cycle of nature and other floral mysteries on an intricate and personal level. I had to make my work personally meaningful, regardless of how others would categorize me. With a lot of dedication and with much effort, I knew my work could be as important as any other art object, be it in glass or any other medium. I would need to hone my skills, take additional creative risks in order to keep my work fresh, and pay more attention to art history and the evolving contemporary art world around me.

The result was a personal, uniquely organic aesthetic that evolved over my career as I began to invent a more complex creative vocabulary.

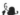

As an emerging paperweight maker living in Mantua, surrounded by the South Jersey glass tradition where stories compared the Millville Rose to the Crown Jewels, I felt a sense of connection with this glass community. Since we lived only twenty-five miles from Wheaton Village it was enlightening to go there and learn all that I could about paperweights, their makers, and American glass. In short, Wheaton Village would become my equivalent to the studio glass movement, albeit without the fine-art expectation. The Mantua area, with its abundance of glass history and natural beauty, offered me intellectual and cultural experiences that would nurture my curiosity and artistic growth.

I also had many acquaintances who were interested in glass, and Jim Friant would become one of my closest friends in the glass scene as we shared the same passions. Jim had grown up in Millville, New Jersey, and would tell me numerous stories about the celebrated glass efforts and of the master gaffers whose reputations were made in and around Cumberland County's glass factories. He proved to be very knowledgeable about the history of the South Jersey glass tradition and, as a graduate of the Philadelphia College of Art's glass program, he was also up to date on the contemporary glass scene. This made him a reliable source of abundant information.

For a while, Jim had been selling his own glass pieces at the craft fairs held at the Head House Square in the Society Hill section of Philadelphia, and occasionally during the late sixties

he would buy my small glass animals and other novelty items and sell them along with his own work. But our friendship was more than that, as he began challenging me to think of art beyond the economics of an object. Additionally, using his small furnace, he would teach me some basic glassblowing techniques, and in return for his help I would assist him in making whimsical human forms in glass, either at the furnace or by lampworking. As we worked, he would speak of glassblowing and lampworking within the framework of sculpture, and just hearing his words and perspectives on creating glass art gave me incredible new insight by elevating my artistic expectations. The most interesting result of the experience with working hot glass at the end of a blow pipe was strengthening my commitment to the lampworking process and opening my eyes to the challenges that lay ahead, as I was still determined to become a studio artist.

Jim, a product of the South Jersey glass tradition, told me an interesting story of something that happened when he was a student at the Philadelphia College of Art. Frank Whittemore, who had left industrial glassblowing to become a full-time paperweight maker, came to the college's glass studio with a selection of his latest paperweights. He showed the students his glass, and after he left, a few of Jim's classmates began laughing and making sarcastic comments about how kitschy and crafty his pieces appeared to be.

As I listened to the story, I became fascinated with the challenge to elevate paperweights out of craft and into fine arts, making them relevant to the mysteries of nature. The irony is that today many collectors enjoy Whittemore paperweights, which are prized in paperweight collections as being a part of the modern American paperweight tradition.

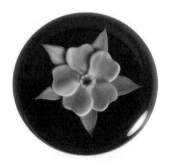

The Studio Glass Movement

Prior to the sixties, glass was primarily used in an industrial setting, but gradually over the past forty-plus years it has become increasingly utilized to create stunning and brilliant works of art worldwide. If one surveys glass art in the major art-craft magazines, one will see that glass is as commonly used today as is clay, metal, fabric, or wood. This growing use of glass by professionals and hobbyists alike can be traced to the educational efforts of Harvey Littleton and to his graduate-students-turned-disciples during the sixties and early seventies. What was once a secretive craft was reinvented in the hands of creative people who used glass as a means of personal expression.

Contrary to the historical tradition of blowing glass, the glass-art students were picking up their blow pipes for the first time with little or no vocational training. Thus, their entry into the glass process proved to be a difficult and an occasionally chaotic endeavor. In due course, though, these first studio glass artists would

discover new approaches and develop different and exciting techniques that would lead to uniquely American creative successes as they began to make objects aspiring to be fine art with glassblowing. In fact, I have always felt that the hallmark of the studio glass movement was the bold and innovative spirit embodied by these early artists who invented imaginative techniques without the benefit of traditional glass training.

These art students either rejected or were oblivious to techniques that had evolved from centuries of tradition as they adopted risky and experimental strategies. The idea was to transcend the utilitarian form and function of the glass objects to make them works of art. Even though they encountered few successes at first, they were willing to persevere through tremendous emotional and physical hardships in order to master this new art form on their own terms.

This hot glass being blown by these adventurous students in the art departments of the growing number of college and university programs was becoming highly attractive in that it offered a fresh approach to self-expression. Certainly the roaring furnace was a great crowd pleaser, its flames most likely engaging the young artist's imaginations and stimulating their sense of creativity and spontaneity. With the freedom to explore glassblowing outside the boundaries of apprenticeship programs, the benefit of the latest technologies, and their eagerness to learn a once-secretive art while unraveling centuries-old processes, students were challenged to see and believe in the unlimited artistic opportunities available in hot glass.

Also impacting art education at this time was the social upheaval caused by the Vietnam War. The military service deferments

being offered to those who were attending college began to fuel an unusually high demand for admission into art schools, especially at the graduate level. So in order to meet the increasing interest and needs of these students, art departments throughout the country enthusiastically began expanding their programs. Essentially, it was a combination of these factors that helped nourish the tremendous enthusiasm for glassblowing during the sixties.

The impression I have of the studio glass movement and its encompassing history will most likely differ from that of Harvey Littleton and his first students, artists that included Dale Chihuly, Fritz Dreisbach, Henry Halem, Kent Ipsen, Roland Jahn, and Marvin Lipofsky. All of these students came to the medium through their education in the arts and were encouraged to float a fine-art expectation over a material process. Littleton's graduates named above went on to establish the first glass-art programs at institutions such as the University of California at Berkeley, the Philadelphia College of Art, San Jose State College, and the Rhode Island School of Design, to name a few. These glass-art programs, which expanded into new art centers, made hot glass hotter and sexier than ever.

The studio glass movement began in 1962, after glassblowing was introduced to those outside the factory setting. In Toledo, Ohio, the self-proclaimed glass capital of the United States, the Toledo Art Museum hosted two glassblowing workshops led by artist-educator Harvey Littleton. The goal was to give interested, creative people — those willing to try something new and different — an opportunity to explore the creation of art by using glass.

Littleton, who at that time was chairman of the art department at the University of Wisconsin, Madison, had wanted

to explore ways of bringing glassblowing out of an industrial environment and into an artist's private studio. This successful transfer would lead, in my opinion, to a cultural phenomenon. His first challenges were to design some type of suitable furnace and furnace-working techniques so the students and artists could work with and manipulate the glass.

During his first attempt to melt glass in his hand-built pot-furnace, Littleton was technically over his head, and it wasn't until Dominick Labino came to the rescue that progress was made. Labino, who at the time was Director of Research at the Johns-Manville Corporation, gave Harvey technical and material support needed to melt and then blow a hot glob of glass on the end of a pipe. Dominick played a role in the workshops' early successes, and in a very poetic way, he symbolized a harmonious melding of art and science. For Littleton and the others, their progress was measured first by how easily or difficult it would be to melt the glass. Their other challenge was to develop new approaches or techniques using modest equipment to get workable hot glass out of a small furnace. There would be numerous trials and errors, but soon glass would be well on its way to becoming a basic material in the service of art-making. It could no longer be ignored or thought of as too difficult or too industrial a material for use by an individual artist in her or his own studio.

In short time the students, soon-to-be glass artists, were blowing bubble forms that resembled cow bladders, asymmetric items, and other non-representational organic shapes. Their unusual approach to art-making and their naïve attempts at this new process was the birth of what has become known, and is sometimes formally referred to, as The Studio Glass Movement. It is

interesting to look back and realize how the curiosity and creative energy of Littleton and students like Marquis turned a once industrial process into a playful, creative experience.

The idea that glassblowing could be a viable process in supporting one's career in the realm of fine art was both a risky and innovative proposal. With Littleton's increased confidence in glassblowing, he began to reorganize his university art program and its curriculum so that glassblowing would be incorporated into graduate-level studies. Littleton's students were eager to follow his art-making ideals and soon began working towards their Master of Fine Arts degrees. These few students of vision were called upon to bring their fine arts skills to their glasswork as they searched for creative expression at the end of a blowpipe. Even though these students and many early artists lacked the technical knowledge usually gained by working as an apprentice or working in a factory setting, their passion for this new and exciting process kept the flames burning.

As these students became glass-art educators, there was almost a proselytizing zeal to attract art students into the new glass-art programs. They began by establishing college level courses, which gave students access to hot glass. This new breed of artists, armed with bachelor's or master's degrees in the fine arts, were now ready to set the world on fire, knowing they were pioneers in this novel, creative experience. The enthusiasm was relentless as instructors and students found new ways of seeing the world through the illusions of glass.

In addition, around this time Littleton encountered Erwin Eisch and the philosophy that was behind Eisch's vision. The two became close friends, a circumstance which facilitated Eisch

becoming a major influence in the early days of the studio glass movement as he helped to define its creative focus and parameters. Starting around 1964, at Littleton's invitation, Eisch made several trips to the United States in order to demonstrate his glassblowing skills and to share his philosophy with Littleton's students. Later, Littleton would comment that it was Eisch who embodied the creative spirit he had envisioned for glassblowing.

In 1984, Harvey Littleton and Erwin Eisch attended my opening exhibit at Heller Gallery in New York City, where at one point during the evening, Littleton gestured towards one of my new botanicals and introduced me to Eisch as being a lampworker. To my surprise, Eisch looked irritated and then said, "No, that is not lampworked glass." At the time I was a little confused about his observation and wondered if he did not understand my process, which was a mix of lampworking techniques and the use of a glory hole — the furnace chamber used to reheat glass on the end of a pipe. What occurred to me was that Eisch was familiar with the centuries-old German lampworking tradition, which produced mostly hollowware in delicate forms. That type of glass was at the opposite end of the spectrum from my work. Nevertheless, I was flattered to think Erwin Eisch had been perplexed by what I was accomplishing and that I was expanding the glass landscape with an often ignored technique.

In my opinion, the most significant lampworked glass produced to date had been worked during the eighteenth century. As a modern-day lampworker, I helped to advance a continuum in glass work that had for the most part, remained stagnant for decades.

It was around the mid-1980s that the impact of lampworking on the studio glass movement started to be noticed, as artists/craftspeople began to express their contemporary ideas by taking advantage of the process.

Again, the foundation of the studio glass movement, not named such until the late sixties to early seventies, was laid by Littleton and Labino. In my mind, what validates these past forty-plus years of artistic glass expression is the significant works of art that have been created and celebrated both nationally and internationally under its banner.

My entry into the glass world predates Harvey Littleton's legendary glassblowing workshops. As a lampworker coming from an ongoing industrial tradition, my emotional and intellectual connection to the studio glass movement would evolve gradually over a period of five to ten years. When I started teaching lampworking techniques and giving slide presentations on my work in a studio glass context, I came to appreciate the movement's sense of community. The artists I had befriended while exhibiting and teaching, and through my involvement as a founding board member of the Creative Glass Center of America (CGCA), were curious as I promoted lampworking as an underutilized process within the glass movement. As I became more socially and intellectually connected with the contemporary glass artists, I demanded more from my work artistically and came to better understand my goal of achieving excellence.

Meeting Littleton

The 1970s saw courageous and heroic changes within the studio glass movement since glass had once and for all escaped its bondage as a material to be used solely in the industrial setting. A growing number of creative people were being attracted to glass, and artists working in glass were becoming more spontaneous and ambitious in their efforts to create sculpture.

All sorts of experimentation with different types of styles and techniques would allow the new wave of artists to take creative risks that could not have been imagined just a few years before. As a factory worker, I was criticized if I made a mistake that resulted in wasted glass and time. The fact that art students could now actually play with glass without concern for the economic consequences while pursuing their ideas was amazing and gave me greater respect for art-making with glass. Later, in the early nineties, while I was teaching at Pilchuck Glass School, a young

artist told me of how he had lobbed a blob of molten glass out of a fourth floor window of his art school in order to film its descent and impact on the ground. Although I have often wondered how that young student turned out, I have come to applaud that level of inquisitiveness and exploration that I once perceived to be a foolish waste of time and money.

The artists, who by now were creating non-functional forms — whether they be large, small, sophisticated, or outlandish — had solidified the reinvention of glass's centuries-old attributes for use in an exciting and viable new context. As the artists became more bold and inspired, they began to rebel and stopped imitating the European and early American glass makers. No longer were they referencing the once popular Tiffany and Art Deco designs, and in many circles catch phrases such as "We don't blow no art nouveau" and "Let Tiffany die" were spreading like wildfire throughout the glass community. In fact, to counteract the past, artists would now refer to their work as "glass art" in order to differentiate it from "art glass," defined as functional and attractive decorative objects made in factory settings. Indeed, "Form, not function" would become the mantra for this new generation of glass artists.

For me, one of the most thought-provoking aspects of the early seventies would occur in 1972 when, at the National Sculpture Conference held in Lawrence, Kansas, Harvey Littleton would declare for the first time, "Technique is cheap." Throughout the decade his philosophical comment would fuel a hot debate within the glass community focused on the question, "Is studio glass craft or art?"

To me, the quote "Technique is cheap" indicated that the central purpose of art was the *idea* that was to be expressed in

the chosen medium, not the medium itself, the processes by which the medium was worked, or the skill required to execute the necessary processes. Stated differently, I interpreted the statement to mean that the idea was more important than the skilled virtuosity required to express it. I found this philosophical approach to art-making in glass fascinating but also somewhat contrary to my own perspective because my aesthetic had been built upon mastering a high level of skill in the processes of glass working in order to execute my ideas. In other words, my work demanded a commitment to technique, which was not cheap for me, because it required years of practice and experimentation to master — and it cost me a nervous breakdown!

In 1974, I traveled to New York City to deliver six paperweights to Jack Feingold, who was and still is the owner of Gem Antiques, then located on East 53rd Street. His specialty, glass paperweights and American art pottery, included a strong selection of modern paperweights by contemporary American makers. A while before my visit, Jack had seen my work and had expressed interest in showing it. I was delighted that he was purchasing my work to display in his New York City booth at the Antiques Center of America.

Once at the center, I walked around the large commercial space which was home to over eighty-four different dealers. It was amazing to see so many antiques in one location, and I was completely surprised and delighted when I came across one of the largest collections of contemporary glass I had ever seen in my life. The booth, titled "Contemporary Art Glass Group," was featuring the glass art of Roland Jahn, James Lundberg, John

Nygren, and Mark Peiser. As I stood there admiring the unusual and interesting blown glass pieces, a young Douglas Heller walked over and introduced himself. He began explaining that I was viewing the glass of a "new breed" of artists. According to him, these artists were exploring ways to advance the glass tradition. Looking back at it, this small exhibit evidenced the beginning of a new national movement. Doug continued to speak enthusiastically about these artists and seemed to revel in sharing information about their new artistic approaches and the fact that new attitudes in glassblowing were now being used to make a different type of art.

After returning to New Jersey, I realized again how much I wanted to be a part of this new, expanding movement. Even though I was committed to the art of paperweights, I wanted to keep a finger on the pulse of the contemporary glass movement in order to understand more fully how glass art mirrored modern art. By staying informed about contemporary craft and design, I would begin to meet other glass artists who would share information about their approach to art-making with glass, and in turn I was happy to share information about my lampworking techniques. These types of learning experiences were exhilarating, and a few years later I would begin placing my glass on consignment in the Heller and Habatat galleries, the two leading contemporary glass galleries in the United States.

In the mid-seventies I was invited to speak about and exhibit five of my paperweights in a contemporary glass survey exhibition at the John Bergstrom Art Center and Museum in

Neenah, Wisconsin. This regional museum, later renamed The Bergstrom-Mahler Museum, is renowned for its incredible glass collection and is home to one of the largest and finest collections of antique French paperweights in the world. I had first learned of this museum from reading *Glass Paperweights of the Bergstrom Art Center*, written by Evelyn Cloak, published in 1966. Now here I was, with my floral paperweights illuminated in the museum's sun-lit atrium. I have to admit I was quite pleased with their appearance and was truly inspired to be included into the larger community of studio glass artists which was attracting more talented people than the paperweight world.

The panel discussion that was part of this exhibition and in which I took part included James Lundberg and two other well known artists who talked about process and the quality of their glass. I spoke on interpreting nature and my love for wildflowers. After our presentations, I enjoyed speaking with the inquisitive members of the audience who shared my enthusiasm for the natural environment. In very short time, it seemed as if everyone had a story to tell about flowers. It was here that I first realized that flowers can evoke strong associations with pleasant childhood memories. It was nice knowing that as glass enthusiasts, we had a common bond, and it was also insightful to learn that my art had the power to evoke emotion. Later, after hearing wide-ranging compliments about the delicacy and true-to-life quality of my floral paperweights, I was especially delighted when the collectors wanted to know where they could purchase my work.

After the exhibit, Pat and I donated those six paperweights to the Bergstrom collection in memory of Walt La Patrick, Pat's father, who passed away at the time of the exhibit. When I think

back to that seminar in 1976, I now realize how seminal the experience was to my emerging artistic career. The list of artists and collectors in attendance, some of whom are no longer with us, reads like a virtual who's who within the history of today's contemporary glass scene. The list included artists such as Charles Kaziun, Dominick Labino, Harvey Littleton, James Lundberg, and Frank Whittemore; collectors and soon-to-be friends Ralph and Evie Goldstein, Jack and Jill Peliseck, and Leonard and Julia Rakow; art historian Paul Hollister, Jr.; and a small group of museum curators, including the Bergstrom's own Gerry Casper.

There was no question that Harvey Littleton and Dominick Labino were the celebrities of the seminar. In my estimation they both deserved all of the admiration they received for what they had set in motion over a decade earlier. It was here that I had the opportunity to meet Harvey for the first time. Although I enjoyed talking with him and hearing his views on studio glass, I didn't know how to take his light sarcasm and was somewhat intimidated by his authoritative persona. To me, Littleton represented a bold future that challenged artists to make their work personal, and even though he was apt to scold those who may have questioned his perspective, I appreciated his kind words about the quality and attractiveness of my lampworked paperweights.

During his lecture, Littleton focused on the financial issues being faced by many artists who were then working in glass. His point of view fascinated me when he began discussing how glass artists were undervalued when compared to other artists working in different media. He then spoke of the art critics who had relegated glass artists to a stature beneath sculptors and painters, which in turn was hindering higher prices for their glass creations.

For sure, this information caught my attention since I had been working my way out of debt for years and I was almost to the point where things were beginning to turn around.

It seemed as if every small step I had taken thus far had led me to this point; for each experience encountered I had learned just a little bit more about myself and about my art. Here during this weekend seminar I realized that if I wanted to become successful within the studio glass movement I needed to do something more, however elusive that realization might be. I knew I had the ability to develop new paperweight designs based on my personal response to nature, but I didn't have the academic background necessary to understand the creative potential of putting my work in a fine art context.

It was over one thousand miles by car from Neenah, Wisconsin, to Mantua, New Jersey, which gave me a lot of time to think about the amazing people I had just met. When I got home, I told Pat how inspired I had been to see and learn so much and of my new commitment to become more informed not only about the glass world, but of the art world in general. Wishing to make my work more significant, I told her I was going to focus intently on reaching my full potential within the paperweight aesthetic and stop thinking of financial survival as my goal. These feelings had been percolating in my consciousness for a few years, but after attending the Bergstrom seminar I was finally going to act on them.

Consequently, I began spending more time in the woods absorbing the lessons Mother Nature was freely offering me. I started studying art history, and I ordered the Franklin Mint's abridged books on tape, "The One Hundred Greatest Books Ever

Written." Even though it would take me three years to get through this classical collection, I loved every minute spent "reading" the books I could never touch and never come to know during my years in high school and technical school.

Here on the brink of transition, I found myself relishing my new outlook while at the same time knowing it was going to be an incredible balancing act between my desire to be more creative and my need to support my family.

During the middle and late seventies, there were major distinctions between the experience of the paperweight world and that of contemporary glass. The studio glass artists seemed to be bolder and demanded higher artistic expectations while modern paperweight makers were mimicking antique French paperweights as their standard. Personally, I believed at the time that the goals of the paperweight makers were less about art and more about making money. It was becoming more apparent that the artists associated with the studio glass movement were demanding more than just mastering their craft while being concerned about the marketplace.

I perceived that the artists within the upper echelon of the contemporary glass movement were striving to place their work in a fine-art tradition, and their challenges were both intellectual and emotional as they pursued their personal ideals of beauty and expression. While the studio glass movement was attractive to a wide range of young, talented people from diverse backgrounds, most of the paperweight makers came from a scientific glassblowing tradition. In time, I would discover another interesting

difference between the two worlds, that being how much more emotionally supercharged the studio glass artists appeared to be, compared to the paperweight makers.

The studio glass movement was coming out of its infancy during the mid-seventies and it was both interesting and exciting to have my floral paperweights included with other studio glass that was being created by respected artists. For me, the only difference between my work and theirs was that I crafted internal floral designs built upon a long-standing paperweight tradition, whereas many of the contemporary studio glass artists were using molten glass to explore form as sculpture.

At this time paperweight aficionados were one of the largest groups of glass collectors, many of whom were members of the PCA. The biannual PCA conferences, held in different cities throughout the US, were very upscale events and attracted serious collectors from all over the country and Europe. While at all but the earliest of these conventions, I would actively reference contemporary glass as a source of inspiration for my art-making, and I took it very seriously when collectors began seeking out my guidance on how they too could begin collecting studio glass. I advised them to introduce themselves to the owners of leading glass galleries — there were about three or four at the time — and to focus on the art and artists whose work appealed to them. I enthusiastically encouraged them to visit the Corning Museum of Glass in Corning, New York, and to purchase books that were now featuring contemporary glass and artists. My suggestions notwithstanding, many of the new and leading collectors of contemporary glass started out as paperweight enthusiasts.

࿈

There appeared to be no limit as to where this artistic movement was headed. The more profound changes I witnessed, the more I became convinced that the movement's impact would change forever the way we regarded glass as a material. I envisioned that glass art had the power to impact our cultural landscape and art history.

In the seventies, a new audience of admirers was being drawn into the innovative and edgy glass artwork now being created by hundreds of artists, many of whom were vociferous with high energy, all pushing the boundaries of fine art using a material normally associated with craft. With newer and more exciting glassblowing innovations, it wasn't long before a smaller gang of talented hell-raisers ascended to the forefront. One of these was Henry Halem, head of glass studies at Kent State University in Ohio. Halem was very active within the glass-art world and was well known for attracting attention with his pertinent advice directed at the glass students. I can still hear him saying most emphatically, "My job as an artist is to challenge collective thinking and to raise hell while I am doing it." I came to respect Henry for his ability to promote excellence and for the way he was able to get creative people to heighten their expectations. Now looking back, I realize how important Henry was on my artistic growth through his articulation of ideas that splashed beyond his students. Along with Halem, other artists who had been toughened by the protests of the sixties also began, quite vocally, to promote glass art as if it were a newly rediscovered phenomenon.

Following these artists and their work were the innovative entrepreneurs who were opening galleries to showcase contemporary

craft art, especially glass art. The galleries that promoted this new movement with the most passion were, in my opinion, Snyderman's Gallery in Philadelphia, Pennsylvania; Habatat Gallery in Dearborn, Michigan; and the Heller Gallery in New York City. These galleries not only promoted the artwork as significant and new, they played a pivotal role in educating the public about this creative art form. Generally, they were less concerned about process and tended to focus more on good art work, which helped to expand the studio glass movement beyond mere glassblowing to a broader genre closer to the realm of fine art.

Initially, most who visited these galleries were affluent supporters of the arts, or professionals; those who were eager to collect art and at the same time make a good investment. However, as galleries began having monthly and annual survey exhibits that featured both well-known and emerging glass artists, the range of prices of the works of art widened and more collectors were drawn into this exciting new art form. Many of these enthusiasts were coming from the world of antique glass. They were intrigued by the novelty of the new glass art and its relevance to our times and they also hoped contemporary glass would be a solid investment.

Even though museums would in time play an important role in expanding the glass movement, it is the artists and galleries that should get credit for the heavy lifting in the beginning. Generally, the collector-artist relationship was forged in a gallery setting and this bond would benefit each of them in meaningful ways.

Another venue that helped promote glass art was *American Craft*, a bimonthly magazine that was a visual and intelligent resource for those who followed the craft world. *American Craft* began to spotlight public exhibits focusing on glass artists

associated with educational pursuits. It showcased the top people in the craft world through in-depth articles and photographs and it highlighted different work by new and emerging glass artists. It was always a great joy when my issues of *American Craft* arrived. By reading the magazine, I became familiar with an artistic vocabulary that celebrated craft as fine art. Basically, it gave voice to artists to share the ideas behind their work. With few exceptions, the exposure artists received from this magazine reinforced and informed people by promoting a visual language in craft with a fine-art point of view.

By the mid-seventies, serious paperweight collectors in the US and England were increasingly seeking out my floral paperweights. And as I traveled to the various paperweight conventions, contemporary glass exhibits, and galleries I realized my reputation as a lampworker and paperweight maker was on the rise. I was being afforded the same status as other studio glass artists who had started working in the sixties. With my emerging status and the fact that my floral motifs were becoming more complex and commanding higher prices, Pat and I began to experience a new kind of financial freedom that had eluded us for a long, long time. We were now living the middle class dream and it was nice knowing we could afford an occasional family adventure and a reliable car. Indeed, for the first time as an artist, I was paying serious taxes, more than during my years in industry and something I was proud to do. Life was good.

I guess I should have been flattered when Franklin Mint executives started wining and dining me in hopes that I would fly to Europe to evaluate three of their glass factories and then design

and consult in the production of ten floral paperweights that would be sold through their direct marketing campaigns. I should have been even more flattered when they said they wanted only the best floral paperweight maker working for them. For compensation, they estimated I would make over $250,000 in royalties, which wasn't bad considering the only other artist who had ever been offered royalty fees was Andrew Wyeth. I was pleased with the Mint's handsome proposals, but I was torn in two at the thought of changing my lifestyle for such a long period of time because Pat and I were dealing with serious illnesses of both of our fathers.

Pat's father, Walter Thaddeus La Patrick, passed away on July 13, 1976, and after dealing with that profound loss, I spent my time struggling to come to terms with the unresolved conflicted emotions I had for my own father. In attempting to do so I would frequently visit Papa in his hospital room, but time was not kind and on November 26, 1976, after I stopped by his room to say "Hello," he gave me a quiet smile, whispered "Hi," and then peacefully passed away. To this day, I believe Martin Francis Stankard had waited for me that night, for it was his way of blessing me and saying I had been a good son. Later, Pat would tell me my father had said that as a son, a husband, and an artist I had made him proud, and someday I hope to figure out why he never said those words to me.

With the stress of my father's death compounded by the fact I had considered selling my art to corporate big-wigs, my anxiety came rushing back, and for the first few months of the new year I was in the doctor's office almost every week with a new and exotic psychosomatic illness.

Wisely, Dr. Wolf, who knew there was nothing physically wrong with me, recommended that I go to the Agoraphobia Clinic

at Temple University's Psychiatric Hospital. Of course, I was absolutely terrified at his suggestion, but I knew if I wanted to reach my full potential and support my family I had to trust him, so off I went for my first appointment. Surprisingly, it only took me one appointment before discovering my symptoms weren't unique, my secrets weren't really secrets, and there was hope for people who were suffering like me. Therapy would take a while, but I began to believe that I could make it over these hurdles and I also felt that my art would be enhanced by this experience.

I decided not to sell my soul by designing and supervising the manufacture of thousands of paperweights for a royalty, no matter how lucrative it could be. By finally getting this monkey off my back I could get back to concentrating on my art, and I could stop worrying that someday I would become a nut case.

In the spring of 1977, while walking along Madison Avenue enroute to Leo Kaplan Ltd. to deliver some of my work, I passed the Contemporary Art Glass Gallery, now named the Heller Gallery. I had read about Doug Heller's gallery in *American Craft* and also heard about it through word of mouth, so I was pleasantly surprised to be here gazing at its assortment of contemporary glass. Looking through the window I was able to see an example of Tom Patti's glass art, and farther inside, I could see twelve more of his pieces all handsomely displayed. From where I was standing on the sidewalk, Patti, who was the featured artist of the month, appeared to have created the most interesting and unusual glass objects I had ever seen.

I needed to move along to Kaplan's, one of my primary paperweight dealers, in order to deliver my work, and little did I

know at the time how supportive and important the Kaplans would be to my career. On the way back to my car, I decided to go into the Contemporary Art Glass Gallery to get a more in-depth look at Patti's work. Once inside, Doug Heller's partner, Josh Rosenblatt, gave me the impression that he didn't expect that I would be purchasing anything, so he left me alone. This allowed me the space to examine the subtle yet creative nuance of each piece. Since I had never seen anything quite like Patti's art, I decided, right then and there, I had to own one. Believe me, I certainly knew the value of a dollar; in fact, I was very frugal, especially knowing how hard Pat and I had worked for our money. I was rather timid as I selected a sculpture that cost three hundred dollars. Yet, after paying Mr. Rosenblatt, I walked out of the door smiling, completely overwhelmed that I had made my first serious contemporary glass purchase.

Soon thereafter, I called Tom and introduced myself as being the proud owner of one of his sculptures. We had a pleasant and enlightening conversation and I was delighted when he told me that I had started my glass collecting in good company. Of the two pieces he had sold at the show, the other one had been purchased by the Metropolitan Museum of Art. I was impressed with Tom's artistic views and soon realized I thoroughly enjoyed discussing his aesthetic with this soon-to-be-famous artist. It's been fun knowing I had insight into Tom's early work and it's been even better having Tom and Marilyn as long-time friends.

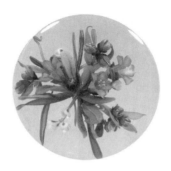

Continuing Education

When the Stankard children were young, our mother would often say to us, "The value of a good education is to lead a person to live a more virtuous life and encourage him or her to help the less fortunate."

I was raised to believe that being well educated was the only ticket to success, and in the crowded Stankard house it was the duty of us children to do well in school. Since getting a good, solid education was promoted as being one notch below being a good Catholic, most of the Stankard children did well in school. As time went on, my siblings amassed an impressive number of diplomas from various distinguished universities. When it came to schoolwork, however, I was not as successful as my siblings, and because I was not the academic achiever I was expected to be, for years I have carried the burden of my father's disappointment on my shoulders. In a sad, almost humorous, way, I'd been seeking his approval with the fear of failure and low

self-esteem, and the irony is that the old man has now been dead for more than thirty years.

Even today when the studio is quiet I think about the part of me who wants to go back in time in the hopes of getting more than a technical education, of wanting to show my father I have led the respectable life he had wished for me. I want to tell him that having a passion for something and the pursuit of excellence are admirable qualities, every bit equal to spending years studying in college.

Yet, the mature part of me wants to speak of a journey, not of self-pity but one of my love of nature, of hard work, and of hope; of shared experiences that have challenged me intellectually and guided me creatively; and of those who have helped me find my path to self-realization.

Back in the early seventies I was not going to let my lack of a formal education define me, so after having spent countless hours walking in the woods I decided that the plant kingdom would be the personal foundation and mystical starting point of my artistic journey. But if I were to become successful, I needed to challenge myself in order to think and build on the best traditions while searching for new ways to infuse myth and beauty into my floral designs. Since I lacked a fine-arts education, out of necessity I decided to design my own curriculum, believing that if I educated myself, my eyes and heart would open to new attitudes about art and art-making. As I had been studying botanical books, and had already graduated from Reese Palley University, I set my course with motivation and perseverance, hoping that each class taken, book read, seminar attended, museum visited, skill observed, or artist talked to would help me in developing and expressing my personal philosophy of art.

I feel that my creativity has been nourished by my childhood fascination of the woods, its mystical virtues highlighting both my fears and sense of serenity. Like Walt Whitman, I believe in its timeless qualities and that the primal sanity of nature can touch the soul. Within its confines I can sense a spiritual mystery and, at the same time, the insignificance of the human ego, and as our natural world becomes increasingly simplified by human activities, I find myself worrying more and more about our collective sanity. To quote Robert Frost, the woods truly are "lovely, dark and deep."

Thus, nature has afforded me endless opportunities to express metaphorically my emotions through floral glass designs and has inspired me to infuse my lampworked glass with natural elements and spiritual ideals. Each morning, like a monk, I savor the sights and sounds of dawn and begin my daily meditation, viewing my labor as a prayer and feeling God evidenced in nature. Yet, this understanding and peace has not come easily or cheaply; because it has taken me years to feel comfortable with my artistic talent.

Prior to my epiphany following the 1976 Bergstrom seminar, I had already begun my foray into learning something about art, and to this day I believe those experiences brought me closer to understanding concepts that in some way improved my skills, my intellectual growth, and my sense of wonder.

Basically, my first step had been to enroll in a sculpture/ clay course that was being taught at Gloucester County Community

College. By doing so I had hoped to learn the vocabulary artists were using to communicate with one another about aesthetics. As luck would have it, my instructor, Joan Balster, had been one of Harvey Littleton's clay students, so we were able to have interesting and constructive discussions about art, craft, and Harvey's glass career. The class proved to be as beneficial as I had hoped, and even though I didn't show up for the last class or take the final written exam, I learned much from Joan's instruction. At least, I now knew that the making of glass art would demand more dedication, more hand techniques, and a unique sense of inventiveness, qualities which had not been mentioned in my previous vocational and scientific glass training.

Soon after the class was over I began listening to classical music, because that is what I thought educated people did and I didn't want to miss out on something special. For the next few months, I listened to and studied Baroque music, my favorite composers being Vivaldi and Bach, and then moved on to Mozart and Beethoven. Almost immediately the music began to lure me into an emotional, expressive world, one I had never entered before, and later, after numerous hours with my ears attuned to greatness, I started to believe that classical music must have been one of God's gifts, as it spoke to my soul. Consequently, for the past thirty-some years, I have lampworked my floral designs to the sounds of these — and other — great classics, the music helping to infuse and complement the spirit that comes alive within me and the flowers I am creating.

Another easy and enjoyable way for me to absorb excellence in glass art was by visiting the Corning Museum of Glass where viewing fascinating objects in an historical context would

awe and then inspire me to work harder. This museum always proved to be a great educational resource, a place to go where I could study the techniques each lampworker had used and note the important challenges the creator probably had to overcome in order to make each of the many interesting pieces. Every time I have gone back to look at the glass objects from centuries past I am humbled, and for years I have competed with the skilled masters who made them. At the present stage in my career I can honestly say that I have enjoyed the challenge of building upon an old tradition while bringing a contemporary touch to my work.

In the early seventies I began attending the PCA conventions. The seminars presented at these meetings were always informative, and they typically included top-notch lectures from well informed museum curators who focused on fine antique French paperweights. These gatherings were held every other year, and they provided an excellent opportunity to meet other PCA members, collectors, dealers, and artists.

All-in-all, I thought I was doing a fairly good job of staying focused on my self-education, yet there were times when I got frustrated with my art-making and there were occasions when my fear of failure clouded my creative judgment. Enter my friend Roy, a struggling real estate agent who introduced me to positive thinking and Napoleon Hill's *Think and Grow Rich*.

If truth be told, this book was actually the first one I had ever read and reread from cover to cover. Not only was it easy to comprehend, I found Hill's suggestions and instructions to be very helpful and insightful. By believing in and steadfastly sticking to his formula for success it wasn't long before I started feeling less afraid and self-conscious, and within weeks, to my amazement,

I was thinking less about financial failure and more about inventing paperweight-making techniques with floral dimensions. In no small way, positive thinking introduced me to a survival strategy that complemented and helped to advance my artistic vision. One interesting aspect of the philosophy is to set goals and think about sacrifices that must be made to accomplish your dreams. Thus, Hill's and others' self-help programs allowed me to survive within the arts because I was able to use my emotional and physical energy to pursue excellence, not self-pity. Incidentally, it was during this time that my sculpted flowers began taking on a Trompe L'oeil quality, their appearance suggesting truth toward nature, which in turn nourished originality in my glass.

At this point, some might view my venture into positive thinking as a form of voodoo, but for me, whenever I have been kissed by the muse, it has happened because I've worked my butt off.

One of the most unusual and provocative exhibits I have ever attended was a retrospective of the internationally renowned French-born American conceptual artist Marcel Duchamp. The arts section of the *Philadelphia Inquirer* had raved about this upcoming exhibit, while our local public radio station promoted it as being the "cultural event not to be missed," a rare opportunity for the public to experience the work of one of the most influential artists of the twentieth century. It was 1973, and with all its high-brow accolades I thought going to this show would be an important educational event, one that would introduce me to excellence in the arts and afford me the opportunity to see a body of work by a significant artist.

Pat and I arrived at the Philadelphia Art Museum late Sunday morning, before 1 P.M. so that we could take advantage of the free admission policy, only to find it already jam packed with enthusiasts, many of whom, I am sure, had come from out of state. At first, I felt the spirit of the exhibit to be up-lifting, but after making my way one quarter through it, I found myself getting irritable and frustrated because I didn't have a clue as to what I was looking at. I even began to wonder if I was looking at art at all! Even with Pat reading the labels and a few of the prominent curatorial statements, I remained confused about the exhibit's artistic value, and then found myself getting really bothered that hundreds of intelligent looking people were obviously enjoying Duchamp's work, while I was just not getting it. Consequently, it dawned on me that others in the crowd must have had some type of knowledge or understanding that I lacked since they were responding to this conceptual art, which was making absolutely no sense to me.

By the time we left the museum I felt pretty stupid about the subject of art, because I honestly believed serious people would not have wasted their time or energy looking at idiotic work, and calling it great art. I knew all I had seen was — and I'm being generous here — utter nonsense to me. Left flabbergasted and confused, I couldn't help but wonder that if Duchamp's art was considered excellent, how the heck was I ever going to figure out what could elevate paperweights to become treasured objects?

With this enigma hanging over my head and believing myself to be a complete zero in art appreciation, I put everything on hold and went back to "reading" the classics on tape. The great books would eventually heighten my spiritual and emotional awe of the mysteries surrounding Sex, Death, and God — themes that would later be woven into my artistic vision.

૪✿

In 1979, after attending a PCA convention in Boston, Massachusetts, I returned to New Jersey and lamented to my good friend Michael Diorio that other paperweight artists were mimicking my paperweight designs and I was frustrated by the situation. Mike simply responded, "It's only natural for people to try and copy the best. If not you, who do you want them to copy?" Over time, Mike's statement would give me the inspiration to keep looking forward, to strive towards new creative illusions while working towards artistic growth, and not worry about what was going on within the marketplace.

Mike was a dentist from Vineland, New Jersey, who after being introduced to my paperweights at Reese Palley's Gallery became an enthusiastic collector of my work. Mike loved nature, and was one of the top ten amateur nature photographers in the country. Through our shared interests we became best of friends, with our friendship starting when he offered to take close-up photographs of wildflowers for my reference. Each portrait was like having fresh native flowers straight from the fields in my studio. I loved the opportunity to be able to examine photographs of detailed root systems, half-open buds, stamens, petals, blossoms, and a wilted leaf or berry. With my new visual resources, I was able to abstract the essence of individual flowers while exploring the minute features of their components. I soon began to create glass flowers that were more detailed and natural looking. Mike's photographic portraits became a wonderful influence on my glass designs, and today I often think about him when lecturing my glass students about the value of knowing your subject well.

One of Mike's favorite pastimes was to present wildflower slide shows to nature clubs throughout the Delaware Valley, and I always enjoyed accompanying him on these outings. I would help "Dr. D," as Mike was known, set up his equipment and, after his presentation, he would introduce me to other naturalists in the room. From these experts I would learn new and interesting information about plants, insects, or life cycles, and in every way imaginable it was nice being included in this small and obscure world of wildflower fanciers. In fact, these excursions became the biology classes and laboratories I had never experienced and Mike was the helpful and caring professor I had always wished for.

Six years ago, in 2001, Mike Diorio died and I am no longer mad about it.

During the seventies, three other individuals significantly enlightened my understanding of art, and in the end each forced me to look at my glass in new and challenging ways. I benefited greatly from insights provided by Flora Mace, Mark Peiser, and Paul Hollister, Jr.

Before arriving at Wheaton Village in 1976 to be its first artist-in-residence, Flora Mace had assisted Dale Chihuly at the Rhode Island School of Design and had helped execute his "Navajo Blanket" series. On one of her first days at Wheaton I happened to see her working on the "factory floor" and found myself mesmerized by her torch-working skills. The process she was using in her art-making was an inventive and brilliant variation of the lampworking technique, one where she was torch-working thin glass rods into a two dimensional design on a sheet

of ceramic fiber. In my mind, her expertise seemed to exemplify the new breed of artist who was bringing a fresh approach to glass-making.

Throughout her time at the Village, Flora's attitude and knowledge about art, her glassblowing skills, her professionalism, and the creative courage she exhibited had an incredible impact on me. Her aura of authority was truly inspiring. Additionally, I was impressed by the fact that Flora didn't mind sharing her techniques with others, which was a far cry from the secrecy of the South Jersey glass tradition I was accustomed to.

What really interested me was her sense of freedom evidenced by her beautiful vases, each one being unique. I had been making paperweights for seven years and the issue of keeping up with demand and making money was competing with my dreams of crafting one-of-a-kind pieces. Being witness to Flora's indifference to the art business was a major eye opener for me.

I thoroughly enjoyed getting to know Flora whose insightful point of view made me look at art-making in glass as the paradigm for my future. Further, as one of the first female glass artists, she inspired my daughter Christine to pursue the same course.

I attended an opening at Habatat Gallery in Chicago during the 2006 SOFA Artfair and had an opportunity to congratulate Flora and her partner, Joey Kirkpatrick, on being inducted into the American Craft Council's College of Fellows. It has been very rewarding for me to have known Flora since the 1970s and to have witnessed her exceptional career in collaboration with Joey. To me, Flora and Joey are the closest things we have to living treasures in American glass.

Like Flora Mace, Mark Peiser seemed to exemplify the spirit of the new studio glass artists, the ones who were willing to take the risks, commit their lives to working with a difficult material, and be good enough to support themselves at it. Mark's journey has motivated and challenged me on all artistic fronts and I don't think I will ever be able to thank him enough for his great example.

In the sixties, young Mark Peiser was typical of the thousands of Americans who had become disenchanted with both the Vietnam War and the robotic mentality of the work place. So Mark decided to leave Chicago and the regimentation of a career as an active industrial designer to live close to nature in the mountains. His dream led him to Penland, North Carolina, and as good fortune would have it, he arrived just in time (1967) to enroll in the first glassblowing class being offered by Roger Lang at the Penland School of Crafts. Mark felt comfortable with all of the technical nuances and was immediately drawn into the process, and within a short period of time he was named Penland's first resident glass artist. By 1969, he was selling his glass at numerous craft fairs and art shows, and the rest is history.

Mark's interests included early American glass, and it is revealing to consider how Louis Comfort Tiffany's paperweight vases influenced Mark's earlier work and how quickly he was able to build on Tiffany's methods in order to create his personal artistic vocabulary in glass. With dedication and vision, Mark began inventing new techniques to capture illusions in glass that were unseen before his entry into the world of glass art.

From my perspective, Mark Peiser's brilliance came from his poetic ability to produce painterly designs on vases as he torch-worked glass rods on the surface and encased the colored glass

into the thickness of the vessel's wall. By using this method, he created diminishing lines for roads, fences, and rows of trees. His vases took on the unique appearance of three-dimensional pictorial images, where each scenic vessel would come alive when viewed in a 360° rotation. With his high degree of skill and originality, Mark became my Ted Williams and watching him out distance Tiffany's rudimentary paperweight vases was like watching Ted hit home runs out of the park.

As a long time admirer of Mark's artistry, in the late seventies I decided to attend his exhibit at the Heller Gallery in New York City. What a thrill, especially when I ended up purchasing his "Swing at Horner Hall," the center piece of the show. After buying it, I had a pretty good buzz going until I realized I was driving home in my beat-up Volkswagen and would have to tell Pat exactly how much I paid for the piece. Strange priorities, but I knew Pat and I now owned an American masterpiece.

What made the paperweight field so vibrant during the seventies were people such as author and dealer Paul Jokelson; Corning Museum of Glass director and author Dwight Lanmon; dealer and author Larry Selman; paperweight specialists Leo and Ruth Kaplan with son and daughter Alan and Susie; Arthur and Theresa Greenblatt; and painter, author, and art historian Paul Hollister, Jr.

Paul Hollister, Jr. was raised in an upper class environment by parents who collected antique French paperweights. Having grown up surrounded by their collections and then having graduated from Harvard University with a double major in science and art, one can see how he developed his scholarly interest and life-long appreciation for finely crafted glass in the decorative arts tradition. With his artistic sensibility and his training as a painter,

he possessed incredible insight into the historical and creative glass landscape, and because of his respected knowledge he often reviewed glass art for several publications, including the *New York Times*.

I had known of Paul Hollister since almost memorizing the pictures in his *Encyclopedia of Glass Paperweights*, so it was exciting, finally, to meet him in 1977 when he attended the opening of a major contemporary paperweight exhibit — and my first gallery show as a studio-glass artist — being held at Habatat Gallery in Dearborn, Michigan. I must admit I was somewhat nervous when he began asking me about my work, but his thoughtful questions indicated he understood how my paperweights were building on a mid-nineteenth-century French aesthetic. Soon we were sharing opinions about the studio glass movement and over the next three decades we would have many more lively discussions, one result of which was that by sharing our mutual perspectives on glass art we came together as friends.

I could count on Paul to be open and honest when critiquing my work, and I found his comments to be challenging and informative, even though sometimes his words felt caustic. Whenever I would see him at glass functions he always had something to say about my latest work. His emotional support and encouragement to go beyond paperweights to explore fresh ideas in botanical designs and to be more adventurous was greatly appreciated. Since he understood my ideas and challenges, he supported and then applauded my pushing the boundaries of the paperweight form as I developed what I titled the "Botanical" series.

At times, Paul was my tutor; he would suggest books to read and museum exhibitions and specific objects to see. Today, I

find myself thankful that I had Paul as a mentor who understood my blending of a historical craft with the philosophy of Harvey Littleton, the high priest and pied piper of contemporary glass.

At Paul Hollister's memorial service, held at the Heller Gallery in November, 2004, it was a privilege to get up and speak about our friendship and of Paul's life by saying he was a curious person who loved beautiful things and wanted to share his world with like minded people. Later, Tom Patti, Michael Glancy, Douglas Heller, and I talked about Paul's intellectual commitment to creativity and of how the remarkable attendance at the service reflected his sharing spirit in the decorative arts from an artist/ scholar's point of view.

Recently, Paul's lovely wife, Irene, informed me she had donated his papers and taped interviews to the Rakow Library at the Corning Museum of Glass. My immediate thoughts were to experience the pleasure of visiting the Rakow Library one day and to spend time revisiting the early years of the studio glass movement by hearing and reading Paul's words of wisdom.

In November of 1979, I went to the Franklin Institute in Philadelphia to view "The Courage to Create," an exhibit featuring thirteen nationally respected artists, including Buckminster Fuller, Jasper Johns, John Cage, and Judy Chicago, all with a reputation for having made an artistic, or visionary, contribution to society. To make a long story short, I had another "Duchamp" experience, for no matter how hard I tried, I just could not grasp the show's point of view.

Yet, refusing to let my lack of knowledge get the best of me (twice) , I returned to the Institute to check out the exhibit a second

time. My brother Martin came along for the adventure and, sensing my perplexity, read the exhibit information and said, "This show is about creative people who have taken risks." After taking the time to experience the show in the context of what he had said, I just stood there quietly, starring at the art and material. Suddenly, I had that rare "Eureka!" moment. I finally got it! For the first time, I visually understood how creative people could push their artistic boundaries to help us discover some hidden truth or undemonstrated capability we didn't know about ourselves. It was profoundly insightful to realize that the creative process is nourished by experimental efforts, and that failure, which before this point wasn't acceptable to me, could be so much a part of the creative process.

I left the exhibit feeling comfortable with the fact that I too needed to start taking some risks. I had been making paperweights for a long time now and wanted to radically change my style to go beyond my traditional efforts. I began day dreaming about how I could invent new forms for my glass flowers and within a few days I started experimenting with shapes, not knowing what would unfold and hoping I would discover something new and intelligent.

Since 1979 had been a good year for me income wise, I decided — as a reward to myself — to take some time off to experiment. Within two weeks, to my surprise and delight, I had found a new path to explore, which was visually exciting but was proving to be quite difficult to develop. Despite the difficulties, once the new forms I titled "Botanicals" became a reality, I knew I was experiencing an exciting breakthrough and had emotionally moved from being a craftsman to an emerging artist. I spent about three more months refining the new efforts, but then I had

to get back to meeting my gallery commitments because money was running low and debt was right around the corner.

When I first started working for myself on a full-time basis in the early seventies, I enjoyed listening to National Public Radio programs being broadcast on Philadelphia's WHYY. One afternoon a professor was being interviewed about ways to achieve excellence. His thesis was that in order to do excellent work, one must know what excellence is. Since I always related everything back to strengthening my artistic efforts in glass, I was inspired to seek out significant work, however it might be expressed, as a way to grow more artistically mature. I believed that by experiencing important work and relating to the quality evidenced by the work, I would grow stronger from the exposure. I hoped to internalize the values that I recognized in the great works and to recapitulate the same depth of human emotion into my own work.

One of the important ways that I sought examples of excellence was to visit museums and galleries across the US and Canada, a practice that I have followed for years and continue to do. Because of my inquisitiveness and my acknowledged need to educate myself, I am intellectually and emotionally comfortable with this pursuit.

By seeing and experiencing great works, I have grown in artistic maturity, which has broadened the foundation I stand on. The value and joy of viewing significant objects, especially when they evidence skilled virtuosity, has been to demand more from myself in the studio. Along this journey to inform myself — now a quest, and expressed in this book — my prayer is that God will bless me and give me the wisdom to help other people.

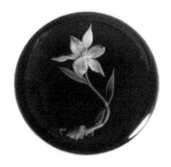

From Wheaton Village
to WheatonArts

When visitors first step into the Museum of American Glass, located at WheatonArts and Cultural Center in Millville, New Jersey, they are greeted by a quotation from poet Carl Sandburg: "Down in southern New Jersey, they make glass. By day and by night, the fires burn on in Millville and bid the sand let in the light." Although Sandburg died before Wheaton Village, the original name of what is now WheatonArts, opened, I would like to think that he must have seen something within the South Jersey glass tradition that touched his soul as much as it has touched mine for these past forty-plus years. How poetic to think of fire melting glass by day and night to let in the light, of sand melting into clear glass, the entire process always seeming so mysterious and magical.

The Museum of American Glass opened in 1967. It is now the centerpiece of WheatonArts, a non-profit, educational institute

dedicated to the culture of craft. The main focus of WheatonArts is to chronicle America's first industry, glass. Frank H. Wheaton, Jr. is credited with establishing WheatonArts both as a tribute to the glass industry and to the glass factory his grandfather, Dr. Theodore Corson Wheaton, started back in 1888. Dr. Wheaton was a pharmacist who made his own bottles; his business eventually became the glass manufacturer, Wheaton USA.

Frank Wheaton's vision encompassed keeping the art of glassblowing relevant and alive, documenting and preserving the heritage of the South Jersey glass tradition within a national context, and demonstrating how American culture has been impacted by the southern New Jersey glass industry. By 1967, Frank's dream to replicate a turn-of-the-century glass-working community became a reality. Today, WheatonArts is situated on sixty acres and contains twenty Victorian-style buildings, including the Museum of American Glass, assorted craft studios, a folk-life center, and retail space that includes one of the largest paperweight shops in the country. The structure that makes the biggest impression on visitors is the 10,000-square-foot cedar-clad work area which is a replica of the T. C. Wheaton Glass Factory. This space is dominated by the gigantic seventy-five-foot-high chimney, like the one in the original Wheaton Factory. The area called the "factory floor" has three furnaces which can accommodate artists and those giving glassblowing demonstrations. Visitors are always amazed as they watch molten glass transformed into art and craft on the "factory floor."

As noted in earlier chapters, during my factory days and early art-making career, WheatonArts, then known as Wheaton Village, was my first window into the world of paperweights and

a place where I met other artists. In this environment, I nurtured a sense of community and pride in glassblowing. Further, with its programs and demonstrations, Wheaton became my art school and both encouraged the budding artist within me and helped advance my career as a studio artist. It was here that I made the emotional transition from being a paperweight maker in the lampworking tradition to becoming an artist within the studio glass movement. So one can only imagine how excited I was when, in 1978, Donald Pettifer, then director of collections at the Museum of American Glass, invited Pat and me to exhibit our paperweights in the contemporary wing of the museum. Wanting to showcase and celebrate my first ten years as a maturing glass artist, he proposed that the exhibit be named "Paul Joseph Stankard, The First Decade." I was so pleased with the offer that after Mr. Pettifer left the house, I was fearful, as usual, that the honor would evaporate or people would change their minds.

The show consisted of a hundred paperweights, including a few very early glass animals and two or three experimental efforts. Each piece in the collection belonged to Pat, and if it hadn't been for her insisting that we save interesting examples of my early work, most of these paperweights would have been sold a long time ago. Pat thought of her collection as our children's legacy, so after the glass was selected for the exhibit I inscribed "Especially to Pat, Love Paul" on the base of some of the weights so I would not be tempted to sell these pieces. To accompany the exhibit, Mr. Pettifer had designed a catalog of the artist's proof collection, which documented all the work that was displayed, and within this catalog was the essay "Paul Stankard's Amazing Paperweights," written by glass historian and art critic Paul Hollister, Jr.

The exhibit's opening night reception was a happy occasion, with attendees including friends of the museum, out-of-state paperweight collectors, my family, and a close circle of friends, many being from the area's glass factories. It was very special to see some former co-workers from my scientific glassblowing days at this gathering and to hear my old friend Marty Gallagher say, "You figured it out Stankard, and I'm glad you're making it on your own. We're proud of you." I was thirty-eight years old and at long last I believed my prayers had been answered, evidenced by the people's reaction to my work, the catalog documenting the exhibition, and this momentous evening.

Before long, the Museum of American Glass was generating regional press coverage that extended to newspaper articles, radio interviews, and several television programs, one being a half-hour-long New Jersey Public Television show that focused on my paperweights and career. I would never have guessed how quickly this kind of publicity would translate into interest in my glass but I learned fast, because right away glass collectors began calling me to acquire my weights. The idea that I was becoming a part of the South Jersey cultural landscape and being treated as some sort of local celebrity temporarily boosted my ego and sense of self-worth, but those feelings would eventually fade with the reappearance of my constant companion, low self-esteem.

Because of the exhibit's success and because museum visitors seemed to enjoy viewing my earlier work, Pat and I left the "Paul Stankard, First Decade" paperweights at Wheaton Village as part of a long-term loan arrangement. Since then, we have upgraded the exhibit to include two additional decades'

worth of work, also on long-term loan. All these paperweights remain in Pat's collection, and when they return to the family it is my intention to have all the glass engraved "Especially to Pat, Love Paul."

When I was invited to be an artist-in-residence for a week at the Village's glass factory during the summer of 1980, it sounded like an exciting proposition, and since I had been on a creative high from having recently given birth to my new botanical series, I thought it would be productive to take some time off from my lampworking in order to experiment with furnace glassblowing. I would not be disappointed.

With two assistants, one an apprentice and the other a master glass blower, both encouraging me to reach higher, I decided to lampwork trees and flowers onto blown glass forms in an attempt to mimic Mark Peiser's paperweight vases. As you have already read, I had been intellectually curious about Mark's techniques and now I was trying to master his approach of lampworking colored glass designs onto hot gobs of glass. In fact, it had been my purchase of his "Swing at Horton Hall" in 1979 that inspired me to explore the idea of cross-pollinating my lampworking skills with other glass-working processes.

By the end of this intense week, with fifty-plus hours of work on the gaffer's bench behind me and eight vases in front of me, I came to the conclusion that Mark Peiser's years of commitment to his process must have matched my years of commitment to floral paperweights. I realized that nobody is going to match that level of excellence without years of passion and practice.

❧

Wheaton Village's original mindset was directed towards the history of American industrial glass blended with a vocational practicality that reflected Frank Wheaton, Jr.'s interests in both manufacturing and teaching young people a trade. The first priority for the development of the Village's vast collection focused upon early American glass. Today, the WheatonArt's collection is a respected national repository recognized for both its bounty of information on the subject and its more than five thousand pieces of glass which most notably documents the South Jersey glass tradition. Here, in southern New Jersey, paperweights are a much admired art form and the historic Millville Rose has not lost its mystique. The legendary Millville Rose came into existence in 1906 when Ralph Barber perfected the use of a crimp to push colored glass into clear glass, and its continuing respect reminds us all that it was once considered the artistic high-water mark of the South Jersey glass makers.

Change is inevitable, and by the early eighties glass art was beginning to make its appearance within the Village's landscape. As new pieces made their way into the contemporary wing, some traditionalists who were unfamiliar with these new art forms challenged the fact that the museum was deviating from its original interest in utilitarian American glass objects. The underlying sarcasm and dead-artist jokes — "dead artists are so much easier to deal with than live artists" — were indicative of the tension between those who honored the South Jersey historical tradition and those who were now embracing the new "crazy" breed of contemporary artists. From my perspective, those who didn't appreciate this transition lacked confidence in their ability to judge

the artistic worth of contemporary glass and chose not to be a part of this new art community.

Hurt feelings would eventually resolve themselves, but in the meantime, and from my point of view, the museum's contemporary glass collection was noticeably weak. Its display consisted mostly of playful and experimental odd-shaped "cow-bladder-looking" forms. Subsequently, in 1981, Pat and I were delighted to loan much of our contemporary glass collection to Wheaton's museum. After the loan arrangements were finalized and our collection was removed from our home, we discovered that we then had empty space that would encourage us to continue collecting. No longer were we faced with the "Where are we going to put it?" lament.

At this same time our family was completed with the addition of our second son and last child, Philip Neal.

For years, I had been building a collection of studio glass art. With each new piece, I felt privileged to be invited into the creative world of each artist I collected, sharing her or his personal vision. This experience often times became a source of great inspiration, especially when I could sense the herculean efforts the artist had brought to his or her artwork. I was fascinated with the philosophy of beauty and the different criteria used to calibrate excellence. I enjoyed contemplating the artwork and considering the qualities that elevated a particular object to the level of fine art. My interest and strongest response is still towards beauty exemplified in the decorative arts, and I enjoyed seeking out objects that evidenced originality and incredible talent that blurred the lines between craft and fine art. Ultimately though, my goal as a collector was to be the custodian of a masterpiece, one whose beauty touched my heart and soul.

The opportunity to share our glass collection with the public has been a source of pride for Pat and me. It has been a joy to know that over the years our collection has helped to educate both visitors as well as staff at The Museum of American Glass. As counterpoint to the rich historical glass exhibited at WheatonArts, in some small way this collection has promoted the world of contemporary glass and its artists.

During the late seventies, I felt a sense of community with struggling glass artists. I realized that without a college or university glass facility, there weren't many places where young, talented glassblowers could go and access equipment in order to be creative. At the same time, I was aware of Dale Chihuly's success as one of the founding visionaries of the Pilchuck Glass Center, opened in 1971 — and renamed the Pilchuck Glass School in 1976 — and of his bold efforts to create a glass community in the Pacific Northwest.

So as a result of being inspired by Dale's foresight, I began to dream that Wheaton Village, too, had the potential of becoming an institution where artists could work and experiment with glass, a place that would provide an environment where the exchange of knowledge and ideas would be encouraged. Without question, I believed that Wheaton's under-utilized facility would be an ideal setting for creative people who wanted to take risks, for those who wanted to work without restrictions placed upon them, and for those who wanted to make major changes in their careers.

Fundamentally, my dream was to have Wheaton Village become a major glass-art center and I started to pursue this objective in the late seventies.

After enthusiastically sharing my ideas with Barry Taylor, then executive director of Wheaton Village, he brought Frank Wheaton, Jr. aboard with the idea. At my invitation, we soon started receiving support and good advice from some of my friends, people such as Paul Gardner, Curator of Ceramic and Glass at the Smithsonian Institution; Doug Heller; and Tom Patti. My friends Sy Kamens and Gerry Hildebrandt, both Philadelphia collectors and businessmen, were instrumental in getting the embryonic center to grow with successful fund-raising activities, which were a major contribution.

Because the newly organized center had its own advisory board, there was always tension between the Wheaton Village board of trustees and the center's advisory board over the allocation of money. The Wheaton Village board favored funding the status quo rather than the new artistic venture, despite the fact that it was attracting substantial funds from sources other than Wheaton Industries.

From its conception to its birth, the opportunity to be involved with the soon-to-be-named Creative Glass Center of America (CGCA) was a delight, albeit a major learning experience. Looking back, I have come to realize that I might have been a bit too aggressive and opinionated during the Center's early years. In hindsight, I didn't fully understand the classic tension between the old glassblowers and the new glass artists. Plus, being so eager to have a major glass-art center in our back yard, I didn't give people's appreciation for tradition its proper respect. However, change is always difficult but the results of this change have more than compensated for the stress it created.

In 1983, the CGCA became a reality and, since its opening day, Wheaton has hosted both national and international resident

artists. Each year, twelve fellowships are awarded to professional and emerging artists, and to date (2007) more than two-hundred-fifty fellows have spent time at CGCA changing, refining, and developing new ideas while experimenting with their art.

In many ways I have been the CGCA's greatest cheerleader, sometimes actually finding myself on the furnace floor giving encouragement to the young artists. For me, visiting Wheaton when the CGCA Fellowship is in session is like attending a major league event. I love the experience of watching art being made, engaging in lively conversations, and taking the time to share my knowledge of contemporary glass and lampworking with the artists. I also enjoy introducing the "artists-in-residence" to the Philadelphia arts scene, and later, over dinner, critiquing the world of contemporary glass.

For twenty-five years this stimulating and challenging environment has been a source of artistic and intellectual joy to me that complements my sense of a glass community. It has been an honor to be involved with these high energy, and at times boisterous, artists. I have always regarded each one as a courageous person, dedicated to his or her creative vision, which for most is also a spiritual journey. Some of the talented CGCA Fellows, now years later, have become members of my artistic family, including people such as Lucio Bubacco, José Chardiet, Karen La Monte, Beth Lipman, Josiah McElheny, Mary Shaffer, Elizabeth Sterling, Mary Van Cline, and Hiroshi Yamano.

The basic mission of the CGCA has changed little since it opened in 1983. It has stood the test of time, and when I look back over my career, one of my proudest achievements is my association with Wheaton and my participation with the Center. I

like to think I've become a catalyst for change along with other creative people who challenged our South Jersey glass community to broaden its horizons. In doing so, Wheaton has become an important player within the national and international glass-art arena, one measure of which is the significant funding support it has received from state and national arts councils.

In the summer of 2006, Wheaton Village was renamed "The WheatonArts and Cultural Center" to reflect its evolution to a place that celebrates artistic diversity. My original idea for Wheaton Village to evolve from its industrial glass focus to becoming a world renowned cultural arts center was culminated with this name change.

Two years ago, while driving from Corning, New York, back to Penland, North Carolina, Mark Peiser stopped in to visit with me. After spending some time in the studio and on the spur of the moment, we decided to drive the twenty-five miles to Wheaton. As I drove the back roads through the South Jersey farm country, Mark and I talked about the early days of the studio glass movement. We agreed how lucky we were to have caught the wave at the right time, how fortunate it had been that we could support our families doing what we loved, and of how much the glass-art landscape had changed over the years, especially with the increasing technical diversity — the more varied processes — being used by talented artists. It was nice to reminisce with an old friend.

Once at Wheaton, we took a tour of the CGCA's collection of glass art, which includes pieces donated by each "Fellow"

artist over the past twenty-five years. Housed in the Museum of American Glass, this collection is of major value not only in documenting the life of the Center but also in showing how the glass movement has responded to alternative processes beyond glassblowing. It was interesting to hear Mark's insightful comments, especially the way he described the body of work as being "democratic" and "experimental" in nature. I guess what he said rang true, as in this collection most pieces are edgier than what one would find in a gallery — they represent artists who were taking risks to develop new ideas in a cost-free environment. At the same time, they're more interesting than many gallery pieces, especially considering that they all were created in the same studio.

Later, we walked over to the factory, where I introduced Mark to a young artist who had no idea who Mark Peiser was. I must admit it was a little awkward at first, but after explaining to the young man that Mark's work was on display in the museum, and that Mark maintains a studio in the Penland area, the artist recalled Mark's work from books and his prominence in the American Craft Movement. After that, the young man acknowledged that he was in the company of a master artist.

On the way home from visiting the CGCA, Mark and I laughed about being old timers, relics, and remnants from another era, and we talked of how the young glass artists didn't seem to know much about the history of the studio glass movement — and wasn't that strange?

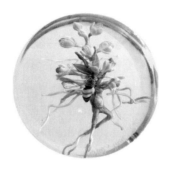

Penland School of Crafts

Nestled into the scenic Blue Ridge Mountains of western North Carolina, the Penland School of Crafts blends creative and administrative spaces into a spiritual retreat, where energetic hands and a respect for things made well are celebrated by all who set foot upon the four-hundred-acre campus. Penland is a national resource for the art of craft-making. Its leadership over the years has helped it become one of today's most influential craft centers in the US, where the boundaries of art are constantly being redefined. For years, creative ideas have been nurtured at Penland by professionals who are willing to teach and share of their hands, minds, and hearts. Penland is an oasis where beginners are connected to their untapped creative energy while experienced artists are rejuvenated and re-inspired. This learning experience brings together people who collectively have respect for each other's talent and reverence for all living things.

Independent artists and educators from varied art programs and universities make up the impressive list of instructors who have shared their talents with their students, each student having a different skill level or aptitude. The school with its diverse curriculum can accommodate a wide range of students, from the most earnest professional in search of an artistic breakthrough to the casual practitioner seeking her or his first joy of making an object.

What was originally named Penland School of Handicrafts began accepting students in 1929. The establishment was started by Lucy Morgan, who wanted to teach weaving to the rural poor as a cottage industry and a source of income. From the late fifties onward, Penland has expanded the number and variety of craft courses it offers while maintaining a good balance between craft and fine art.

Under its second director, Bill Brown, Penland reinvented itself in the sixties in response to the new attitudes and expectations being made upon crafts and the artists who were making them. One of his bold decisions was to ask Bill Boysen, then a student of Harvey Littleton in Madison, Wisconsin, to come and create a new glass studio at Penland. Penland established the first glassblowing facility in North Carolina in 1965, and placed it in an unassuming 10-x-20-foot, tin-roofed shed with almost non-existent walls and a floor made of sand. Soon, Brown initiated a two-year artist-in-residence program which over the years has seeded a very vibrant community of studio artists who are now living and working in the area.

Today, Penland's curriculum varies in scope from a two-year core-student fellowship program to more condensed courses,

with sessions running from one or two weeks to art-making "concentrations" lasting over two months. Penland's offerings have grown increasingly popular, each course designed to help the individual artist who wishes to learn craft techniques advancing his or her art-making career or sense of creative well-being. Most classes are filled on a first-come, first-served basis, with a lottery system for the most poplar offerings. The summer sessions are varied and popular, and it is here where artists and hobbyists from all over America come to bond with other like-minded people. They get the courage to make life-altering decisions by interacting with creative people who choose to express themselves with their hands. Some call this the Penland Spirit.

For over seventy-five years now, Penland has attracted thousands of beautiful souls to her mountain-top plateau. Located in rural Mitchell County, North Carolina, she stands sentinel as an intellectual, emotional, and spiritual resource for anyone who has an interest in crafts or craft-making. A statement made by Lucy Morgan, "Working with one another in creating the good and the beautiful," is what keeps Penland vibrant; it is this sweet, unpretentious sentiment that is the underpinning of the Penland experience.

In 1986, I was forty-three years old with my career in full bloom when Mark Peiser called to ask me if I would be interested in teaching a lampworking class at the Penland School of Crafts. I remember wondering out loud if I was actually capable of teaching anything to anybody, to which Mark commented, "Of course you're qualified to teach. The quality of your work makes you qualified." He went on to say that there was a strong interest

in paperweight-making and lampworking techniques. This was to be the first lampworking workshop offered at the school. Ginny Ruffner had taught lampworking at Pilchuck the previous year, and now Penland invited me to offer a lampworking course which focused on soda-lime glasses. This was the beginning of the lampworking workshops which has substantially increased the popularity of the process nationally and internationally.

The longer we discussed what was needed to set up a functional lampworking studio, the more intrigued I became with the idea of promoting techniques for working soda-lime glasses in an experimental setting in order to expand the limits of contemporary glass. I found myself telling Mark that I loved the idea of capturing the attention and spirit of the studio glass movement, even though I would be promoting a process that was considered the bastard stepchild of glassblowing. Plus, I told him that after having spent a week as a resident artist at Wheaton Village, I knew there were major artistic possibilities to be discovered when the lampworked glass process and components were combined with blown, cast, or fused glass. In the back of my mind during the entire conversation was my desire to promote lampworking as a viable, creative way to expand the technical vocabulary of the studio glass movement. Penland, with its experimental environment and reputation in art-making, would be the perfect location to achieve my goal.

I told Peiser I would have to discuss this ambitious undertaking with Pat, since this would be my first time away from home without her and I wasn't sure how she would feel about being alone with five small children while I was away having fun teaching glass. Around this same time, Doug Heller had stopped

by the house to join me on our way to a CGCA board meeting at Wheaton, so Pat asked Doug about Penland. He spoke of the prestige associated with the invitation, the benefits of being with creative people who had different perspectives, and the great opportunity to promote one's aesthetic. After hearing his words, Pat became more comfortable with my going but in truth I can't remember a time when she wasn't supportive of my efforts to advance my career.

With Pat in agreement, I next focused on my concern that by sharing my techniques, imitators would dilute or diminish the significance of my personal artistic style. For years I had worked in a world of secrecy and since teaching seemed to be contrary to the basic traditions of my livelihood, I decided to call Larry Selman, one of my major dealers, and my mentor, Paul Hollister, Jr., for advice on how to deal with this inner conflict. Both believed I would gain artistic maturity from the experience and after considering their positive and thoughtful comments, I made the personal decision to be open and share my knowledge and techniques. Moreover, if I were going to teach, I would embrace the spirit of the studio glass movement, which meant going against the tradition of secrecy that had for centuries permeated the glass-making tradition.

When I finally accepted Mark's invitation I had absolutely no idea that this decision would set into motion one of the most significant turning points of my career. As events unfolded, however, this remarkable experience of teaching at Penland would introduce me to the joys of interacting with talented people and would help me re-connect to my core belief that God's gifts are enhanced through sharing.

૪

With my car fully loaded with equipment, I began my 630-mile journey south. After driving though Virginia's beautiful Shenandoah Valley, along Tennessee's scenic secondary roads, then into the Blue Ridge Mountains of western North Carolina, I found Spruce Pine, a small town of 2,500 people. Even today when I return to that area I am still amazed by the number of white-painted Baptist churches, the tobacco fields, and the odd-looking drying barns that dot the picturesque landscape. For years, I have thought about one day setting up a studio in this bucolic countryside where houses are perched on hills or nestled near streams. In fact, I have often dreamed of having a summer studio near Penland.

From Spruce Pine, I drove the six or seven miles to Penland, and arrived on campus June 1, 1986. What a sight to behold, as I was touched by the beauty of the land where native flowers bordered the fields and mountain laurels, in full bloom, dominated the surrounding woods. In truth, my first glimpse of Penland's setting was so inspirational I would spend the next five years in my studio, experimenting on and off, searching for a way to sculpt the mountain laurel blossom in glass. This plant is considered by many to be North America's most attractive native flowering shrub. After finally getting it right, my glass mountain laurel blossom has come to symbolize to me the mature aesthetic and artistic freedom I garnered from my Penland experience.

As I started building the benches in my Penland studio that first Saturday evening, I realized I had absolutely no idea what to expect from myself or the class. My game plan was to give two slide lectures, introduce Paul Hollister who I invited to be a visiting

lecturer, and demonstrate lampworking until I dropped from exhaustion. I had little time to ponder that, because George Bucquet, who at the time was Penland's glass artist-in-residence, soon wandered into the studio, introduced himself, and began to help me set up the equipment. George, who is today a highly respected glass artist, was a pleasant, cultured young man and during the entire week was unbelievably helpful. He knew how and where to beg and borrow, in order to obtain the needed materials to get a project off the ground.

In due course, George and I built the benches out of two 4-x-8 sheets of plywood, mounted them on four wooden saw horses, and then connected the gas and oxygen hoses to the torches from oxygen tanks on either side of the table. Other artists drifted in, a few bringing tools or adding torches to the bench, each helping to shape the work area so that by late afternoon Sunday, Penland would be in the lampworking business, with the studio looking rather interesting.

On that beautiful Sunday morning I got up early and left my Penland house by 7:30 in hopes of locating a Catholic Church in Spruce Pine. It was a quiet, short drive and once I arrived in the center of town I stopped to ask a local man where I might find a Catholic church. He just shrugged his shoulders so I went on a little bit farther until I found a Baptist Church where several people had already started to congregate about its entrance. As I approached the group with my inquiry, they looked a little perplexed or gave me a blank stare, but in short time a nice man walked towards me and said that Saint Lucien Church was only a couple of minutes away. He then kindly bid me to join him for their service. I declined, but later I wished that I had accepted his invitation.

I found the small Saint Lucien Church in a quiet, quasi-residential neighborhood. The church had posted a 9:30 mass, so I decided to tour the town before the service, all the while wondering what drove its economy and questioning why I was seeing so many retired railroad cars. By 9:15 I was back at the church. Once there, I followed a few of the early folks into the smallest church I have ever visited, and after sitting down in the back for a few minutes I couldn't help but notice the chatty friendliness of the twenty or so parishioners, a far cry from what I was used to. I enjoyed the service very much and after it was over I found myself thinking that its ecumenical dimension had been influenced by the strong Baptist ties found within the area.

Just before leaving the church, an elderly man walked up and asked me where I was from and what was I doing here. After I responded to his questions, he acted rather bewildered and immediately introduced me to the priest by saying, "This fella is from that Penland place." A sudden hush fell over the four of five people surrounding the priest. The next voice I heard was a middle-aged woman declaring that she had heard of "strange goings-on happening up there at that Penland place." From where I was standing, it didn't appear to be the right time to get involved with what seemed to be a Penland public-relations problem, so I invited the priest to come visit me in the glass studio any time he wished and then asked him if he could recommend a good place to get some breakfast.

The food turned out to be pretty good and the waitress at the local restaurant was pleasant, but after telling her why I was in this area she could only manage a half-smirk before uttering, "I hear they have wild parties up there with all kinds of sex orgies

and things like that!" I immediately replied, "Wow, lucky me," and as I grinned back at her and turned around to leave, I just happened to notice some of Saint Lucien's congregants now seated right next to me. Unfazed by my probable slight, I left the diner thinking about those who I had met at Penland and pondered the irony that they were probably more moral than we who had just attended church.

Penland's 1986 summer catalog contained the following course description, which was read by my thirty-one students before they chose to sign up for the lampworking workshop.

Session 1: 6/2-6/6: Paul J. Stankard:

"In Pursuit of the Super Great Paperweight" is designed for artist/craftspeople to explore glass imagery lampworked for encasing in clear glass. Slides of important antique French paperweights will be studied. [According to Stankard] "I believe lampworking is an unexplored process by artists that will have a major impact on contemporary glass. I am looking forward to a workshop stimulated by creative interaction and risk taking giving lampworking a renewed vitality. The meaning and import of my work have varying degrees of personal feeling interwoven in my day to day labor. Isolated they are: meta-physical, the most personal, seeing God in nature. Second is reaching my full potential with my mind and heart; and third is the continuation of a tradition with pride in craftsmanship. By feeling

comfortable with my craft and by understanding the limitations of the form, I hope to bring a new contemporary experience to the centuries old lampworking tradition."

Paul has long been considered a master of the floral paperweight. Tuition: $185.

At 10 o'clock Monday morning I was quite nervous as I sat down on my bench to begin my first, ever, live demonstration. Making the anxiety just a little worse was knowing that I would be demonstrating to more than thirty people, both students and visitors, including some high-profile glass artists, among whom were Gary Beecham, George Bucquet, Matthew Buechner, Kenny Carder, Mark Peiser, Richard Ritter, and Yaffa Sikorsky-Todd. I also wasn't too thrilled about the possibility of turning out a failed effort in front of the younger artists who included Marco and Tim Jerman, Rollin Karg, and Michael O'Keefe, along with two paperweight makers just getting started, Chris Buzzini and Randall Grubb.

With the group settled down and with nothing to lose, I lit the torch and began lampworking what I hoped would become a delicate yellow sessile-leafed bellwort. Coincidently, the colored glasses I was using came from the Spruce Pine Batch Company, a local supplier. I had designed the bellwort, which is native to the Northeast, to be a single bloom nodding off a leafy stem, with a root bundle supporting one of my human forms. The use of human forms in the root masses of some of my florals stems from the association of humans and plants in medieval herbal art, and it symbolizes a mythical, anthropomorphic dimension I sometimes attribute to the roots of plants.

While I was developing the glass flower, those watching began asking questions, some of which centered on imagined

technical problems and potential obstacles I had never even encountered before. Also, they wanted my opinion about making work personal, inventiveness, and about everything else imaginable. Even though their interest in my process was intense, at times I felt challenged by their degree of inquisitiveness. Fortunately, because of my familiarity with making this native flower, I was easily able to answer questions and work at the same time.

Once my design was completed and looking like the image I had envisioned, I was ready for the encapsulation process. With the assistance of Bill and Sally Worcester, two glass artists from Hawaii, I melted and then dropped the soft clear glass onto the preheated glass bellwort. Things were going rather nicely when out of the blue, Mark Peiser, who was standing five feet from me with his arms folded across his chest, blurted out, "He just dumps it on," to which I replied in one of my loud half-laughs, "That's right Mark, I just dump it on, and that's the secret." I guess everyone was amazed at the simplicity of the act, which had taken me years to perfect.

After the demo was over, I said a prayer to myself in thanks for having achieved a sweet result, all the while hoping the class had no way of knowing the pressure I had felt or how I had tried to make the entire process look effortless. The paperweight was soon placed into the annealing oven and at that point I think I was on one of the greatest creative highs of my life. Then, because I was sweaty, I headed for the shower. On the brief walk back to the resident house I was proud, realizing that I had demonstrated that lampworking could become a new frontier on the contemporary glass scene, which in theory I had always known to be true. Further, I had promoted my magic tricks in the service of new

ideas and I was proud to have finally lifted the veil of secrecy surrounding the paperweight-making process.

As we regrouped Monday evening, the studio was buzzing in a festive atmosphere of lampworking and glassblowing. This combination of the two processes, the music, and the beer and wine drinking became the format for the rest of the week. As I stood there soaking it all in, the new director of Penland, Verne Stanford, came over and I mentioned to him that I thought Penland needed to improve its reputation among the locals. He agreed that something needed to be done. I wasn't quite convinced that his joining the local Rotary Club was going to solve the entire problem, but it may have been a baby step because, since that time, Penland has worked hard to gain the respect of Mitchell County residents. In fact, today Penland hosts an open house for the public early in the spring, an anticipated annual event that now attracts hundreds of people eager to create their own little masterpieces in one of the institution's numerous studios.

In truth, the irony is that art-making is a spiritual quest, and is as close to prayer as one can get to glorifying the Almighty. Being an artist requires dedication and sacrifice as a calling equal to that of the clergy. Beauty is the visible form of good, just as good is the metaphysical condition of beauty. Society needs artists every bit as much as it needs scientists, teachers, laborers, fathers, mothers, and ministers. Thus, in my philosophical world, Penland's role in art education is a noble one.

Of the many terrific experiences I had during my first year as an instructor at Penland, a few seem to consistently resonate

in my memory. Foremost among these is the amount of bustle and action that took place within the studio — the glassblowers at the furnace, the lampworkers on their benches, and the ten blazing torches. Also, students from around the campus and visiting area artists floated in and out of the studio, and their combined input added noticeably to the collective spirit. With all of the diverse activities going on there was such an incredible celebratory atmosphere that the glass studio became a center of unbelievable creativity, especially for the new lampworkers who were turning to an under-utilized process to undertake interesting experiments.

Next was the exceptional lecture presented by the fascinating and, as already discussed, very learned Paul Hollister, Jr. Not only did Paul provide the class with a wealth of information about the history of glass and the status of the contemporary glass movement, he also became an important resource in the studio, once even assisting me in one of my lampworking demonstrations. Also of note was Gary Beecham's thought-provoking talk on ancient glass, his knowledge of the subject exemplifying the scholarship that is inherent within the glass community.

One of the most stimulating events of the week was the intellectually intense, emotionally charged group discussion that was held in Ridgeway Hall, the morning the class was joined by Paul Hollister, Jr., Harvey Littleton, Mark Peiser, Richard Ritter, Mark Peiser, and others. The topic of conversation was supposed to have focused on creating glass art while advancing one's aesthetic as a studio artist. Like all provocative discussion groups, however, we soon branched out into a wider range of subjects, from a civil chat about economics and the self-supporting artist

to an energetic debate about craft vs. fine art, with Harvey Littleton still pontificating that, in spite of everything, glass artists were not being appreciated on a fine-art level. It was an invigorating way to begin the day and I knew that if I was learning a lot then the students, too, were receiving some pretty high octane information. Just having this group here, in one room, had brought a new and exhilarating dimension to our collective mindset, the effects of that morning's get-together eventually complementing our singular efforts.

Finally, the roots of my now-twenty-year emotional connection to beads and bead-making were planted while I was teaching in Penland's glass studio. It was during my first day there when Donovan Boutz offered to show me how he made lampworked beads, a technique that was unfamiliar to me. His subsequent demonstration immediately caught my imagination because he was doing something so interesting and creative. Quickly, I seemed to sense that the ease of the process would be a real show-stopper for both beginning and mature artists alike. Needless to say, before that Monday was over I had lampworked and decorated a few beads, and before the week was over, glass bead-making had taken on a life of its own with several members of my workshop. The jewelry students, who had drifted in and out of our sessions, began focusing on this new style of lampworking.

When I think back to those days, I have little desire to take credit for the burgeoning interest in bead-making that followed our creative week there, but I am proud of my pioneering efforts which helped to promote enthusiasm for lampworking at Penland. And to those who question the merit of bead-making as art, I say

that excellence transcends categories, and whether the piece is a glass sculpture in a fine-arts tradition, a murrini, a marble, a goblet, a paperweight, or a bead, if one's work is personal and is made well, it will be respected by informed art enthusiasts and other artists.

Invariably what I enjoy most about bead-making is the skill and imagination it takes to create one. Bead-making, however, is not a time consuming process, a fact which allows me the freedom to give my miniature treasures away as healing fetishes. I incorporate beauty into each bead I make and I believe that beauty heals; the mysterious power associated with a healing bead has to do with the serenity one gets while contemplating the beauty of the crafted object. Additionally, I enjoy thinking of my beads as symbols, and when I give one away, which is very seldom, I bless the recipient and pray for his or her well-being, each bead having its own potent healing power.

I first heard the words "lampworked glass" shortly after enrolling in the Scientific Glassblowing Technology program at Salem County Vocational Technical Institute in 1961. As a teenager, these words sounded strange, almost stupid, and I couldn't believe they described the intricate process used in making scientific glass.

The term "lampworking" gets its name from when, centuries ago, oil lamps were used to melt and shape glass rods and tubing. The glass would be softened over a lamp's flame, its wick fueled by whale oil, while a foot pedal pumped air into the flame, the process generating temperatures to over 2000° F. Even though

this method was successful enough to produce an impressive array of what are now treasured glass objects, most coming from middle Europe, this interesting variation of glass-making reached its apex during the nineteenth and twentieth centuries. The surviving body of work produced back then can easily match the best objects made today, despite the fact that we have the advantage of newer technologies.

I have always enjoyed being a student of historical lampworked glass and even today, when I visit the Corning Glass Museum's collection, I marvel at how the artisans worked without the benefit of gas/oxygen torches and computerized annealing ovens. It's hard to fathom how the ancient lampworkers maintained such a high degree of quality and artistic acuity as they created figures and dioramas with only the use of oil lamps.

Today, solid glass rods and tubing, measuring anywhere from less than a millimeter in size to over two hundred millimeters, are routinely lampworked into glass equipment, which for over one thousand years has benefited scientific exploration and experimentation. These rods are also used in glass art and sculpture. In my estimation, there are so many varied lampworking techniques that if I didn't understand the nuances of most of them, I would swear this glass-making process was magic.

In the mid-1980s, I noticed that Susanne Frantz, then curator of the twentieth-century glass collection at the Corning Museum of Glass, was using the term "flameworking" in place of the word "lampworking." That a person could replace a centuries-old term with another less ambiguous word was a bold move on her part, and I was both impressed and amazed that someone in a curatorial position could have so much influence within the world of glass art.

Before I left industry to be out on my own, I had always identified myself as a glass artist or lampworker. Now, with a newer up-to-date label, I wasn't sure why I felt the urge to resist a change in terminology, even though the new description sounded more appropriate for the process.

So, when I returned to teach at Penland in the summer of 1987, the first thing I did was to try and put to rest the issue of whether we were going to refer to ourselves as lampworkers or flameworkers. As it turned out, some of the class had mixed feelings, some were oblivious to the matter, and some were angry, like young Robert Mickelsen, now a celebrated glass artist, who articulated both his and my attitudes when he asked, "Why is it that people think they need to rename a long standing tradition and expect us to go along with their new-found verbiage?"

We needed to vote. Before we did, I spoke up and said that it had taken me damn near twenty-five years to get comfortable with describing myself as a lampworker, so the term was all right with me, to which a young student yelled back, "Stankard, you sound old fashioned." Interestingly, I thought to myself, "Maybe you're right." Perhaps I had been taking glass terminology just a little too seriously.

The vote turned out to be a tie, and so I broke it by siding with the flameworkers — since I didn't want to be thought of as old fashioned. Henceforth, I have embraced that term, but the irony of the entire debate was that many of us really didn't care about labels, especially me.

Today the terms are used interchangeably, with "lampworking" making its way back into the vocabulary of numerous glass artists.

>&

While I was at Penland I had the opportunity to visit some of the local private glass studios, among which were those of Billy Bernstein, Rob Levin, Mark Peiser, Richard Ritter, and Yaffa Sikorsky-Todd. I had met Richard Ritter at a Habatat Gallery opening in 1977, and by 1986 he had become a superstar with an international following. I had been a little bit intimidated when I discovered that he was going to be sitting in on my workshop. But, his generous support throughout the week was sincerely appreciated, and after seeing him make his intricate murrinis and complexly layered glass pieces, I could see why his art was considered significant.

Today, Richard and his wife and glass partner, Jan Williams, maintain a studio in Bakersville, North Carolina, just a few miles north of Penland. By virtue of their kind-hearted professionalism they are among the most respected senior statesmen within the Penland craft community and are held in esteem throughout Bakersville for their generous spirit of volunteerism. Richard's willingness to teach numerous classes at the Penland School of Crafts and his recent governor's appointment to the North Carolina Council for the Arts shows how much his influence has had, and will continue to have, upon future artists. Indeed, as a mature artist, Richard has become a guide on a creative continuum advancing the boundaries of glass art.

Mark Peiser, Richard Ritter, and everyone else who I had the honor of working with during my first two teaching experiences at Penland allowed me to see what attending an art school would have been like.

At Penland, one learns by sharing and interacting with other talented people. You learn by making mistakes, you learn by doing something you have never done before, you learn by doing those things you didn't think you could do, and you learn by failure. Penland is a place where you can make ridiculous art and ask stupid questions because people are neutral and non-judgmental. Here the food is always good, the weather is perfect in the summer, the talented instructors can usually be found when you need them, and, the staff isn't a major pain in the ass. If you're dyslexic or sense you are different, nobody gives a damn, just come on in and work with us. Penland offers creative freedom in what is otherwise a sometimes harsh world.

Penland is a place where kindness and good will float over a beautiful landscape. I thank you, Mark Peiser, for your professional respect, your friendship, and for inviting me to join the family at Penland, a national treasure for crafts.

Back to Salem

Since those first experiences at the Penland School of Crafts, I have taught flameworking and encapsulating techniques at several other fine institutions, among which are Urban Glass, Pilchuck Glass School, Corning Glass Museum Studio, North Lands Creative Glass Center (Scotland), Ezra Glass Studio (Japan), and Rowan University. And, on alternate years, I still teach at Penland. Yet, from 1997 onward, one of my greatest joys has been teaching glass courses at and being an art advisor for my old alma mater, Salem Community College. As one of its adjunct instructors, I have become a resource to a new generation of multi-cultured aspiring artists. I am able to share my knowledge, the pitfalls, and the joys of flameworking with those who not only want to learn new hand skills but who really want to improve their lives through creating beauty. Teaching at Salem is also a nice way to honor those who have helped me in the past, it's the

perfect way of keeping up with current trends in glass art-making, — and, being around young people keeps me young.

Believe it or not, telling stories about my early struggles to pass my glass course requirements, and the fact that I failed glass-blowing my first year at Salem, usually inspires my students. When some of them get as flustered as I did, I remind them that working with glass is all about perseverance, it's about commitment, and it's about developing personal and imaginative techniques that may or may not require traditional skills. I tell them how frustration is ever present in the artistic process and of how I can relate to their battles with required academic courses and the feeling of being misunderstood. I encourage them to take art history, design, and drawing classes, because these courses can nourish a more courageous path towards art-making. Most of all, because some are giving this their last shot at college, I praise their effort and understand their uncertainty because, many years ago, I was walking in their shoes.

As a teacher, or like a convert proselytizing the one great faith, I believe the best way to promote excellence and enrich the visual senses is by taking the students on field trips to art museums and by promoting great literature, both of which have significantly inspired my creative side. In fact, I've compiled a list of my favorite books that I credit with heightening my artistic maturity; and when handing my students the list which appears on the facing page, I remind them that "many successful artists have read these books."

What I bring to teaching is my professional experience, which has been informed by years of angst and overcoming hardships, both in the academic setting and on the factory floor. I

- *American Visions*
 Robert Hughes
- *Art and Fear*
 David Bayles and Ted Orland
- *Concerning the Spiritual in Art*
 Wassily Kandinsky
- *Glass: A World History*
 Alan MacFarlane and Gerry Martin
- *Philosophies of Art and Beauty: Selected Readings*
 in Aesthetics from Plato to Heidegger
 Albert Hofstadter and Richard Kuhns
- *The Autobiography of Benvenuto Cellini*
 Benvenuto Cellini
- *The Gift: Imagination and the Erotic Life of Property*
 Lewis Hyde
- *The Letters of Vincent Van Gogh*
 Vincent Van Gogh / Ronald de Leeuw (editor)
- *The Nature and Art of Workmanship*
 David Pye
- *The Story of Art*
 E. H. Gombrich
- *Ulysses*
 James Joyce
- *Walt Whitman: A Life*
 Justin Kaplan
- *Zen and the Art of Motorcycle Maintenance*
 Robert M. Pirsig

compare my glass-art students to novices at the beginning of their holy journey, not unlike the monks and nuns who are enlivened by an inner voice. Their need, like mine, is to express beauty like a spiritual calling and to be bold risk-takers regardless of the obstacles in front of them or the indifference society seems to have placed upon them. In my students, I see my reflection — and we learn from each other.

It was in the late nineties that Dr. Peter Contini, President of Salem Community College, with enthusiasm and willingness to embrace the future, sought my input to help energize the Salem glass program. My recommendation was that the school expand the scientific glass facility to include glass art. With Dr. Contini's leadership and the support of a strong advisory board, Salem expanded its glass program to accommodate a robust demand for glass-art classes. The new glass-art program has since attracted a new breed of bohemian-style students, which has energized the campus and brought a hip notoriety to the college.

Dr. Contini also was my cheerleader when, in 1999, I proposed that Salem Community College host an international flameworking conference, a program that would bring together internationally respected glass masters, art scholars, and museum curators. To my delight, the proposal was so enthusiastically supported by the administration at Salem Community College that it has become an annual event. Today, the International Flameworking Conference is a well respected seminar that brings together a glass community made up of glass professionals, students, and glass enthusiasts, within which excellence is promoted,

new ideas are discussed, and scholarly lectures are presented. The newest equipment and materials are showcased, and students are afforded the opportunity to meet the masters, watch demonstrations, and learn about technical problem solving.

One of the most remarkable results of the conference is that Salem's library has become the repository of the world's largest and most comprehensive video collection which documents internationally respected glass masters demonstrating their craft. Thanks to the conference, the College is now attracting global attention for its dedication and willingness to teach innovative approaches to lampworking, kiln casting, and cold-working. This expands hot-glass-working skills that benefit both art and science.

A few years ago, Dr. Contini presented me with the Salem Community College Distinguished Alumni Award and soon thereafter a gallery in Salem's new glass center was named "The Paul Joseph Stankard Gallery." When I think about those awards, with gratitude, I can't help but get a slight chuckle when I contemplate the irony of it all. As I connected to glass, it enhanced my self-esteem because I felt proud to be making something important. When Mr. Donaghay told me so many years ago that I should leave Salem and join the army, I said "No," because I knew glass would be my life.

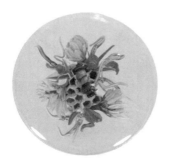

Living Amidst
a Personal Collection

Tucked away in the farmland of southwest Virginia reside two genteel Southern glass enthusiasts, their monastic homestead surrounded by stunning landscapes. When looking out of their easterly facing solarium, one is afforded a panoramic view of the Appalachian Mountains. In their attractive sun room a light-splashed glass cabinet displays an in-depth grouping of American paperweights representing a historical collection of work ranging from the early makers to the more modern makers. When I visited, I was delighted to see my 1976 "Trilaflora" design in addition to two of my paperweights from the eighties attractively arranged amid the group.

The home was beautifully lived in, and as we moved from the paperweight collection towards the center of the living area, it was fun to see whimsical toy characters — suggesting grandchildren — decorating historic New England Shaker furniture. As we moved through the living area I was delighted to see an

additional collection of studio glass enhanced by a dramatic glass-block wall letting in natural light which amplified the brilliance of the collection. It was rewarding to see three of my recent glass sculptures alongside a Harvey Littleton conical intersection, a Richard Ritter floral core, and a Mark Peiser paperweight vase. To be represented in these collections — one surveying earlier glass paperweights and the other a major contemporary glass collection documenting the Penland glass community — was a beautiful metaphor that paralleled my creative journey from paperweight maker to glass sculptor.

One of the few exceptions to the Penland focus was the dramatic Preston Singletary blown-glass "Raven" with a bold, mystical gesture creating an aura of Native American spirituality. This theme was enhanced by the work of nationally respected Native American artist N. Scott Momaday.

Magically suspended from a skylight above the display area floats a Therman Statom sculpture, the most thought-provoking piece in the collection. Formed of aluminum branches with crystal artifacts attached, it becomes a dramatic gesture complementing the architecturally innovative sky dome. Its ethereal presence defies scale and offers a balanced counterpoint to the beauty and tranquility of the objects below. Therman, who teaches intermittently at Penland, designed and installed this piece to be site specific, and the story goes that he had trouble keeping his mind on the installation process because he was trying to make friends with the cattle who were gazing at him through the glass windows.

The overall impression one gets after experiencing this collection is of a thoughtfully arranged intuitive response to beauty,

scale, and content, while simultaneously celebrating excellence as visual poetry. It was an epiphany to realize that glass art from the sixties grouped with recent glass works, could offer such a fresh visual statement. To me, the collection documented time and technology that evidenced sacrifice and dedication by a group of pioneering artists and those of the next generation who brilliantly followed in their footsteps. Like the paperweights displayed, this collection of fine art represents an American reinterpretation of a centuries-old European craft and is visual proof that the great masters are no longer European.

It is enriching to have found collectors with whom I could intelligently speak about both paperweights and studio glass art, and the artists who created the work. Most satisfying to me was being able to divulge my old esoteric feelings about the negative bias towards flameworking and paperweights within the studio-art-glass community.

I met these collectors though my friendship with Richard Ritter and Jan Williams, and it's great to know that in the Appalachian country one of my cloistered floral botanicals is handsomely placed next to one of Rick Beck's towering cast-glass ship borers.

The Twenty-First Century

If I am able to stay in the game for another ten to fifteen years, I would like to be thought of as an American artist of the twenty-first century, my legacy being the contribution that my glass art has made to the American decorative-arts landscape. Not that it matters a whole lot, but given the choice, that would be my wish. As a mature artist, my present work is the most ambitious of my four-and-a-half decades of glass-making. It's sweet when artists, especially emerging ones, tell me how I have inspired their career choices. When I think back on how Frank Whittemore's paperweights first challenged me in the mid-sixties, I realize how grateful I am to have followed a path which bestowed upon me the freedom to make personal choices in the pursuit of beauty. It is rewarding to give back to the art community, a culture that has nourished me throughout a long artistic journey. The greatest honor I have ever received came from my

peers when I was inducted into the American Craft Council's College of Fellows, as part of the class of 2000.

I derive wonderful inspiration when visiting the Corning Museum of Glass and being surrounded by its collection of 45,000 objects that visually celebrates a 3,500-year-history of glass. As a matter of fact, there have been numerous times I have found myself standing in front of one of their ancient examples and wondering, "What would an archaeologist think if she or he were to unearth one of my glass pieces a thousand years hence?" Would someone in the future be able to understand my symbols, would anyone be able to grasp the visual language found on my word canes or in the root figures or my masks? It's my hope that if examples such as "Floral Bouquet with Mask" or "Cloistered Botanical Assemblage" are still around in the next millennium, the person holding or viewing the piece will be able to unravel the environmental theology and values of this twenty-first-century artist.

Over the years the Corning Museum of Glass has afforded me an important in-depth glass education and for years the museum's connoisseurship and commitment to excellence has been well worth the 270-plus-miles I have driven, so often, to get there.

It was no surprise that after months of anticipation, Pat and I were eager to attend the opening of the Corning Museum's new (2006) exhibit, "World Within: The Evolution of the Paperweight." On the way to Corning, we reminisced about the Museum's 1978 stunning exhibition, "Flowers that Clothed the Meadows," which was a high-water mark in the paperweight world. Upon arrival, we experienced 188 objects ranging from antique French paperweights to contemporary works grouped in the Museum's West Bridge Gallery. The most interesting pieces, which were not traditional

paperweights but rather works that highlighted paperweight-making techniques, included a Tiffany vase, works by Mark Peiser and Richard Ritter, and two of my botanicals and an orb. Seeing my recent pieces in this context gave me the great pleasure of recognizing that perhaps they were seen as representing the evolution of a new stage of the paperweight concept.

My lasting appreciation of this Corning exhibit derives from my deep-rooted commitment to celebrate – in a Whitmanesque spirit – the ordinary as extraordinary. I had dedicated my life to advancing the art of the paperweight, and to see examples of my recent work placed within an exhibit devoted to the evolution of the form convinced me that I had succeeded in taking what many considered to be ordinary – that is, paperweights – and expressed them in extraordinary ways.

Recently, the National Crafts Council of Ireland invited me to exhibit my glass and to be the keynote speaker at its 2007 exhibit, "Wild Geese, Irish in America." The seminar took place within the walls of a Kilkenny castle, located outside of Dublin, and I fulfilled my life-long dream of visiting Ireland. My only regret was that my mother, Mary Florence Stankard *nee* McGivney, who had always dreamed of visiting Ireland, wasn't alive to accompany me on this new adventure. For this special occasion, I submitted ethnic stories that had been handed down to me in childhood to reference my work and to be published in the catalog that accompanied the exhibit. In part, the catalog stated:

> The opportunity to share my art with the people of
> Ireland honors my Irish ancestors. Americans of Irish

descent have a unique relationship with their Mother Country. My work, for example, has been informed by, among others, James Joyce and his deep layering of human feeling into words. I hope to reach that level of intimacy with my interpretation of nature in glass. My work is about Sex, Death, and God, and I express these feelings through the life cycle of plants translated into glass. My hands have been manipulating glass for over four decades. In the beginning, this was about mastering a craft. Slowly, I found ways to express a special interest in the plant kingdom, and as the designs evolved, I found myth under the leaves and among the roots. For me, as I near the end of my career, the artwork is more personal than at any other time. I think of myself as a monk in the studio celebrating God's mysteries, and have come to love the Trinity as mysticism.

Poetry in Glass

For most of my adult life I have tended to gravitate towards book stores, and once there I usually look at the wildlife or floral books before wandering over to the poetry section to peruse those shelves for something of interest. I always feel at home in this part of the store because as a child the only thing I enjoyed reading was poetry. More likely than not, this is probably due to the evenings after dinner spent with my mother who would often read a poem to me. Once she finished, I would then read the poem myself. Since I had good memorization skills I could easily sound out the words and connect them to the rhythmic cadence of the poem. For the most part, I was able to understand the meaning of the poem, and soon I was taking great satisfaction in knowing that I could read and comprehend words.

After finding myself facing an invisible wall that had slowed my creative process to a snail's pace, I returned to the reassurance of poetry. In my mid-forties, I was hoping that a different point of view or lyrical voice could re-inspire me to be more

creative. Perhaps poetry could help me see life in a new light. Perhaps it could help me get over the frustration I was feeling about my lack of artistic progress. Perhaps I might be lucky enough to find a community beyond glass that would engage me.

Consequently, I started looking at poetry books and in no time found myself purchasing Mary Oliver's *American Primitive*, which had a Pulitzer Prize seal on its cover and a jacket endorsement extolling her as a great poet who celebrated Nature. After spending numerous hours reading her work, I realized I had been greatly moved by her gifted ability to transform plants and animals into holy entities. I began spending all my spare time reading others' poetry in order to calibrate their depth of feelings with my own personal experiences. Pat would later suggest that my obsessive plunge into poetry was most likely the result of a mid-life crisis, but I believed my new passion had more to do with originality and artistic growth.

Accordingly, I kept reading poetry, prayers, and invocations, those that not only honored Nature and Mother Earth but which kept me emotionally connected to a wealth of words that touched my heart and spoke to my imagination. One of these poems, "Inversnaid," written by Gerard Manley Hopkins over one-hundred-fifty years ago, still remains in my memory. In its last stanza one is reminded of just how important the woodland experience can be. I believe Hopkins' words to be noble and I share that sentiment with my grandchildren as often as I can.

"What would the world be, once bereft
of wet and of wildness? Let them be left,
O let them be left, wildness and wet;
Long live the weeds and the wilderness yet."

More and more frequently the words of William Blake, Robert Frost, Seamus Heaney, John Keats, and W. B. Yates became my artistic nourishment, my vision becoming more enhanced and more energized by the holy words these men had written. Soon I found this reading being transformed into an urge to bring poetic form to my glass-making. From this need to express myself I created the word canes. These fragile glass mosaics are made of small white glass rods, each one containing a word that is fashioned in black glass. In essence, words such as seeds, fertile, scent, moist, decay, and wet are transformed into rice-sized slivers of glass sealed onto green-glass tendrils, then camouflaged into a floral design to suggest the sensual dimension of the plant kingdom. In a remarkable and provocative way, it seems to me that these glass canes have become a permanent record of my necessity to bring poetry into glass, of a way to express my fascination with Nature and my evolving environmental theology.

When I think of great poets, my list expands to include Emily Dickinson, T. S. Eliot, Alan Ginsburg, D. H. Lawrence, Theodore Roethke, Gary Snyder, Dylan Thomas, Walt Whitman, and William Carlos Williams. Foremost among them, Whitman's words have both challenged my core beliefs and reinforced my love and need for learning — and, in appearance, he also magically resembled my beloved grandfather. Whitman's poetry has changed my life, and believe me, if Saint Augustine could reconcile Greek philosophy with Christianity, then surely I can reconcile Whitman with my Irish-Catholic upbringing.

Walt Whitman's poetry celebrates man, Nature, and democracy with his expressive words that are perhaps more powerful

today than when they were first written during the middle of the nineteenth century. His respect for all of creation and his mystical beliefs, two profound themes articulated in his masterpiece, *Leaves of Grass,* are expressions of divine wisdom that resonate in my soul. His poem "Song of Myself" is a dissertation on the spirituality of living organisms, his view of life as a creative flow, and his response to Nature and its native flowers, insects, and birds — broadly encompassing yet elusive concepts that beckon me to enter his world of imagination and deep thought.

I derive much satisfaction from the way Whitman takes seemingly ordinary objects and transforms each one into a miracle. A common flower symbolizes the mystery of living things; to him, "A morning glory at my window satisfies me more than the metaphysic of books" (Stanza 24, "Song of Myself"). Whitman celebrates the native flowers he chooses to write about, such as the pokeberries and the common mulleins, which to us are quite commonplace. In Stanza 31 of "Song of Myself," he even rejoices:

> I believe a leaf of grass is no less than the
> journey-work of the stars,
>
> And the pismire is equally perfect, and a grain of sand,
> and the egg of the wren,
>
> And the tree-toad is a chief-d'oeuvre for the highest,
>
> And the running blackberry would adorn
> the parlors of heaven, . . .

I am neither wise enough nor educated enough to grasp all the nuances of Whitman's poetry. I have to work at what I do get from it. Yet, the freedom of his writing style and the breadth of

his subject matter provide such vivid sensory stimulation that I am able to embrace the depth of what he is conveying. Sometimes I even feel as if he is writing directly to me. In his poem "The Learned Astronomer," the astronomer grows weary and dizzy while listening to a lecture so he walks outside and starts gazing at the stars. Hence, this poem becomes a powerful metaphor, one that demands a personal response and respect for the mysteries surrounding us. Who among us wouldn't find a lecture meaningless when compared to a firsthand experience with the stars?

For me, Whitman is a guide with a roadmap, a spiritual being and a magical source of inspiration. He celebrates Mother Earth and delights in the miracles of God. He takes the most ordinary experience and elevates it into an extraordinary one. The lyrical way in which he relates to everything within the cosmos makes him the ultimate environmentalist. He challenges me. When I walk in the woods after reading his poetry, my eyes are more open to Nature's wonder, to the beauty of each leaf, blade of grass, or berry on the vine. To Whitman, Nature is harmonious and imbued with mystical powers. "Give me solitude, give me Nature, give me again O Nature your primal sanities!" he rallies in "Give Me the Splendid Silent Sun."

What Walt Whitman accomplished with words, I seek to do on a visual level. Through my glass sculptures, I want to articulate my own views and concepts about Nature. My work is driven by a deep respect for the natural environment and all that dwells within it, so my challenge has been to match Whitman's depth of feeling with my own passions and to match his gift for words with my creative hand skills. Thus, I want to craft my visual art to be no more accessible than Whitman's poetry. By this I mean,

readers need to bring something to his poetry in order to under-stand the subtleties that can be easily missed at first glance. And with my art I hope the same holds true — that viewers will bring with them the same sense of openness, curiosity, and maturity they bring to one of Whitman's poems. It will take patience to unlock my glass symbols, to go beyond the material.

Whitman began his career as a self-educated carpenter, but his remarkable journey, his ability to eloquently express himself, and his efforts to honor and pay homage to Nature would reward him with extraordinary wisdom. By the age of thirty-eight he had dedicated his life to a body of work that celebrates people, uni-versal truths, and the creative spirit. His poems extol the virtues of men and women in all walks of life, and he excludes no one. He even writes about the body in ways — that even today — I would be too self-conscious to talk about. To him, the body is sacred and he accepts completely the wholesomeness of all liv-ing creatures engaged in their sacred, cyclical journeys.

I can identify with Whitman's creative courage and I can easily relate to his singular commitment of being true to one's vision. He suffered, he sacrificed, and at all costs he protected his artistic integrity. His perseverance along with his need to ar-tistically express his inner most feelings about Nature are stan-dards I have come to emulate. Indeed, even today, my most re-cent artistic statement reads, "I am interested in blending mysti-cism together with magical realism to suggest organic credibility." I celebrate nature's continuum and her primal sanity in glass, hop-ing to share these feelings with the viewer. The poetry of Whitman, the literature of James Joyce, and Emerson's transcendentalism have informed my work and my being.

$

My need to write poetry was borne out of a frustration with my inability to manipulate glass to correlate with my thoughts of immortality. Yet, the more I immersed myself in language, the more I derived curious satisfaction from arranging words in my head and on paper. Before I knew it, I was writing short poems that demanded a different level of artistic effort, the reward being a new way to express my emotions. Like the Greek Orthodox mystics reciting the "Jesus Prayer," I was able to flood my mind with words as I sensed Nature within my heart.

Increasingly, I started walking on my woodland property. Usually I carried a stool so I could be comfortable while meditating in my small nature preserve. Here in my outside studio I could experience the flora and fauna, and sometimes I would revisit my childhood memories of the special hiding places where I would fantasize about various spiritual apparitions. This setting became more important to me than my glass studio, with the woods nurturing themes of personal discovery and strengthening the spirituality I bring to my artistic endeavors.

No doubt writing poetry would be a challenge but I needed an emotional outlet, I needed to express myself, and I needed to feel that familiar creative tension and bliss again. Even as I write now, I'm not sure what initiated this driving impulse to compose poetry, but it was as if one day I intuitively knew that I had to do this. Later, I would sense the poetry coming from my soul, the writing of words helping me to articulate my beliefs about Sex, Death, and God.

In the writing of poetry I discovered a love for crafting words as an innovative way to express my life-long fascination with

Nature. My poetic vision would become as meaningful to me as my glass art, both mediums allowing me to turn my feelings and prayers into a celebration of Life.

Hence, I have decided to share with you a small sample of my poetry. And based upon my creative struggles and the anguish it took to express myself from the heart, I now believe poets to be among the most noble of artists.

"Bramble," the second poem I wrote, initiated a series that would take me nine years to complete. While sitting next to a blackberry bush I discovered the pleasure of meditating on a plant in order to better interpret it with colored glass and words.

Bramble

Fertile decay nourishes
arched stems, green
growth; blossoms soften
thickets hooked thorns;
showy stamens satisfy
June insects; hairy
drupelets swell to juicy
Blackberry

In this next poem I wanted to convey the essence of creative labor. In my mind, object-making is a spiritual activity, a conduit for seeking insight into the creative process. When I hold a piece of glass in my hands I believe the glass holds the memory of the best work from the past, and with skill, the craftsperson can advance excellence to the present. The title, "Laborare Est Orare" is borrowed from the Benedictine Monks' Latin motto, which means "To labor is to pray."

Laborare Est Orare

Labor's mystic feelings
seeks boundaries
as risk envelopes beauty
in tension.
Skill becomes materials'
memory, grace gives desire
expression.

I was quite surprised one year to discover some Indian pipes growing in my woods, and as a result I wrote the following poem. This piece eventually became the first one to be interpreted into glass.

Indian Pipes

White mystical totems
in moist shaded woods
offered fluid folk cures
to those who understood.

Saprophytic flowers, cluster,
nodding in light
feed off decay
develop upright.

Black-spotted pods
drying pastel brown
stand erect through winter
nature's totems in the ground.

A while back I installed in the studio an observation bee hive, which was mounted on a wall with a one-inch plastic tube connecting it to the outside. While the bees were free to move around as their normal activity dictated, I watched and recorded the following.

Honeybees

In the hive
honeybees
breed
virgin queens.

Scented foragers
guided by sun
dance their language
about harvesting
to be done.

Dusted murmuring bodies
rubbing pink clover
wing repeated visits
lured by field's odor.

Nectar
gathered in sun
made into honey,
nature's continuum.

On several occasions I would ride my bicycle to the Mantua conservation area in order to experience moments of quiet. The pond with its water lilies was so peaceful that, when approaching it, I felt a solitary sense of mystery.

Water Lilies

Swamp's soft current
charges the quiet pond.

Black earth's wet edge
harbors sounds in sedge.

Air bubble ripples
halfway to floating green.

Underwater
under mud
tubers nurture pads,
upright buds.

White petals circle
fragrant core, wilted,
submerged,
spongy berry mature.

Poetry in Glass

This poem, like a prayer, remains untitled. I think of it as my artistic statement.

Receive this glass
it holds my memories
crafted blossoms
suspended
in stillness
to be pollinated
by your sight
anticipating your touch
through time.

Among my fondest memories is picking blueberries as a child in North Attleboro, Massachusetts. When I would take them home to my mother, she would look into my container and say, "Paul, you're a good blueberry picker because you don't have any green berries or leaves in your bucket." Then, she would bake the best blueberry pie, ever.

No Green Berries or Leaves

Walking north
along the tracks
past Lily pond,
thistles mark
the narrow path
through grass
moist in morning dew.

To the blueberry woods,
where filling a quart container
brought praise
for no green berries or leaves,
as a mother smiled
on a child's labor.

Now gathering blueberries
like a prayer
the first taste
a communion,
the mystery shared.

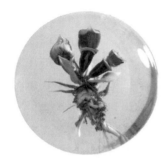

It All Came Together

I estimate that from 1969 to 2007 I have made approximately five-thousand-five-hundred glass pieces, mostly paperweights, with botanicals and my newest form, the orb, numbering a few hundred.

Now, as I look back to the beginning of my career as a studio artist, I recognize that I have benefited greatly from working with a small network of dealers and galleries. I have kind thoughts for the first dealers who purchased my earliest paperweights for resale. While working long nights and most weekends in our small utility room I probably didn't sell more than fifty pieces. Today, when I see these paperweights back on the market, I am delighted, since each one brings back a specific memory of the time I spent making it. It's hard to believe I started selling them for ten dollars apiece and two years later people were paying me fifty dollars for the best ones. I didn't own many hand tools or have much information about paperweight-making techniques. These early

efforts remind me of how strong my urge was to be creative and how difficult it was to follow that creative voice.

In an unusual way, the marketplace has facilitated my journey, and the experiences I have had within it have supported me while I matured as an artist/craftsperson. Now, some thirty-five years later and having overcome countless educational challenges, I realize that even without an art school education, I have grown with artistic authority because of my personal vision, innovative spirit, and disciplined work ethic. Success in the marketplace, within the context of good art and design, is by no means an indication of how significant my work has been. In fact, the business side of art-making often dilutes the artistic expectation by replacing it with the opportunity to make money. Throughout my career, the enigma of delicately balancing and protecting the artistic integrity of my work with the need for money to improve my family's life and my future art, has been one of my greatest concerns.

I have always felt a part of a community while working in glass, first as a scientific glassblower, then as a paperweight artist, and in the eighties as a pioneer who promoted flameworking techniques within the studio glass movement. Over the years I have had the opportunity to collaborate with numerous artists, meet collectors, and work with gallery owners and dealers. I am grateful to my audience which has consistently responded to the interesting ways I have developed and refined my floral motifs and am appreciative of all who have supported my evolving glass art.

Whenever a gallery owner or paperweight dealer calls to inform me they have sold one of my pieces, the mood in the studio becomes celebratory because that means the artistic circle

has been completed; someone has acquired and visually derived pleasure from what I did in the studio. When I hear stories that my floral glass sculptures have been passed down as family heirlooms, I am emotionally touched. To have one of my objects pass through time, as a symbol of a beloved person or an event, is a blessing.

My commitment to support my family, and therefore my need to survive as a glass artist, has kept me a busy man. When I reflect on the many wonderful people I have met over the years, I think more often than not about the collectors who have supported my vision. It's quite a dynamic and diverse group, made up of those who have varied artistic backgrounds and differing points of views and collecting strategies.

Annie and Mike Belkin selected their first of my paperweights in 1983, and over the intervening years have assembled the finest and most comprehensive collection of my glass art. Their support of me and my work, and Mike's mentoring me on the business end of things, can almost be likened to a modern day variation of renaissance patronage. Also, I appreciate the generous way they have loaned their collection to numerous museum exhibits throughout the country. In fact, it was their collected works added to those of Mike Diorio's which made possible Ulysses Grant Dietz's 1996 book, *Paul J. Stankard, Homage to Nature.*

In the mid-eighties, an unknown, middle-aged man drove three hours south from Allentown, Pennsylvania, to Wheaton Village in Millville, New Jersey, in order to select and purchase one of my floral-bouquet paperweights. After making his selection, he tearfully told the saleswoman that the paperweight was

for his wife who was going to have major surgery the next morning. He then went on to say that even though his wife had admired my glass work for several years they were of modest means, so this was going to be his special gift of love to her, one that he also hoped would help in her healing process. In time, she would write and tell me about her joy in receiving one of my floral-bouquet paperweights and how that special gift helped her recover.

Sister Mary Brunner doesn't own a piece of my glass, but it's letters like hers that make me believe my life as an artist has been worthwhile.

"Mr. Stankard, yesterday I had the privilege of viewing an exhibit of your paperweights at the Leigh Yawkey Woodson Art Museum in Wausau, Wisconsin. The piece that most moved me was a small cluster of jack-in-the-pulpits with roots that held two human figures. A love for the details of our north woods is in my blood thanks to my parents who instilled this in me until they died. When my dad was in his nineties he told me that he would like jack-in-the- pulpits on his casket. He and mother loved them and had transplanted some from our woods to the north side of our garage on the farm. When Dad died in May of '96 I went to the woods in hopes of fulfilling his little wish but could only find the green shoots poking through the dead leaves of the forest. It was a little too early for the blossoms so instead I planted some jack-in-the-pulpit bulbs that remind me each spring that he and mother are very present to me in their New Life. When I looked into your jack-in-the-pulpit paperweight I could not hold back the tears. It reminded me that the two of them gave me roots to enjoy all of life. And there they were supporting their favorite flowers! It was a moment of grace, with God and them. I will

never forget it and I want to thank you for making them so present to me through your work. . . . I had a fifty mile trip back to the north woods and thanked God for my sight over and over again as I drove home. My eyes were filled with so much beauty in such a short time. . . .

Gratefully, Sister Mary Brunner [February 22, 2006; retired Franciscan Sister, Green Bay, Wisconsin]."

Over the years I've had the pleasure of working with several assistants, and I've greatly appreciated all of them for having helped me become more expressive throughout my career. David Graeber, who I hired in 1989, and my daughter Christine, who started a year later, are the ones who have worked with me the longest. In the ensuing years, my daughters Pauline and Katherine and my son Joe also have joined me and, as of today, these five fine people are still helping me run an efficient and exciting studio. Philip Neal, my younger son, lives in Wisconsin and is an industrial designer.

All of our artistic activities take place within my dream studio, which was built in 1997. What had started out as a fairly modest project somehow turned into a 3000-square-foot building. With its expansive large windows on every available wall, its high steel-beam-supported ceiling, and its heated floors, this structure has come to symbolize my optimism and the realization of how far I've come from the tiny utility room where I first started making glass elephants.

In the studio, I promote excellence like a holy doctrine. The staff knows by now that "getting it right" and "making things

well" are the two corner stones upon which I have based my career. As they balance quality with creative spontaneity, I encourage and applaud their individual visions and artistic commitment. Christine, Pauline, Katherine, Joseph, and David develop their individual designs and help each other encapsulate these designs as a team. I'm proud to believe I've mentored five talented people, four of whom being my children, to become virtuosic glass artists.

Recognizing both where I am in my career and my desire to help my assistants, we collectively have formed Stankard Studio. Stankard Studio is a team-driven concept that provides an opportunity and a means for my assistants to continue and expand their individual artistic endeavors even as I inevitably wind down my participation in the studio.

My loyal and hard working assistants divide their time between helping me with my work and taking on new and different leadership roles in Stankard Studio for their own designs. To encourage and support their creative journies, I have started taking Mondays off, giving them complete control of the studio. Ironically, by doing so I've discovered that I can't stay away and end up spending my "time off" organizing my archival material.

Generally, in the mornings my assistants and I discuss plans for the day before critiquing work that has cooled down in the oven and attending to other individual responsibilities. Christine is the artistic director and the public voice for Stankard Studio. My second daughter, Pauline, is a sculptor and focuses on casting in addition to attending to the administrative tasks. David, Katherine, and Joseph are primarily focused on hot glass. In the end, however, titles in a studio are superfluous because

everything we do depends on team work and taking on a variety of tasks.

It's exciting to watch my assistants grow by setting aside the time they need to nurture their own creative abilities and to see their artwork being collected under the aegis of Stankard Studio. As their paperweights are offered in the glass world, I am proud of their talent and hard work. They make the personal sacrifices needed to keep a studio going which will give them a beautiful life. I believe they fully understand the concept that good work depends on the sincerity of their hands, minds, and hearts all working together in unison.

As I think of their future, I'm beginning to find myself daydreaming about a more relaxed schedule. Lately, I have been thinking about Pat's occasional comment that she has had to share me with the glass world. On some levels, I know I have been obsessive in my commitment to a personal vision, one that demanded most of my physical and emotional energy. I have also had to confront a truth that isn't comfortable to admit, that maybe I could have been a better husband and parent. Yet, with my five grandchildren living nearby, I'm going to make the best of this new opportunity and am focused on a better balance between glass-making and being a loving grandfather.

However, I have tried to live my life by my mother's philosophy imparted to me as a child, which has been to educate myself in order to be better able to help people though sharing.

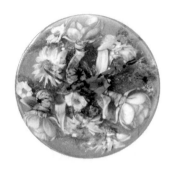

Epilogue

The narrowest hinge of my hand puts to scorn all machinery.

— Walt Whitman

Of all that I own, my most prized possession is an old wooden box which holds my grandfather's engraving tools. Philip Alexander McGivney grew up in Brooklyn, New York, and moved to North Attleboro, Massachusetts, as a young man to learn a trade that led to a small engraving business. As a young boy, I enjoyed visiting my grandfather's room before dinner, a place where he sketched art nouveau floral designs on the margins of newspapers. I loved our time together, especially listening to his stories about his travels on horseback and standing by his side as he sketched his favorite intricate designs that decorated sterling silver tableware years earlier. He lived to be eighty-seven years old, and when I went out on my own, my mom gave me Grampy's

wooden box, complete with his tools. Sometimes I would hear my mother say to her friends, "My second son Paul, he's good with his hands, just like my father."

When I look at my grandfather's worn engraving tools I can sense how much he cared for them and I can sense the respect he had for his craft. When I handle them, and feel the comfort of the grip, I know I am close to the spirit of the man who I loved as a child. Grampy's varied assortment of tools is sacred to me because they indicate through their wear that a master craftsman was respected and worked with them.

For forty-five years I have sat on a bench huddled over a Carlisle torch, my simple yet effective hand tools allowing me to cajole and manipulate delicate glass rods over a gas oxygen burner. Designed to keep the heat away from my fingers, these sturdy instruments allow me to rotate and shape the hot glass as gravity pulls it into the flame. Because they can interact with hot glass at 2000° F, they become the extension of my hands, the flameworker's primary tools. In order to create even the tiniest glass component, they must connect with the hot glass as I use my skills and timing to shape it.

Unlike the metal, clay, wood, or fiber artist who can actually touch his or her materials, I am distanced from mine and have often found myself secretly envying those who can feel their art evolve. Many times throughout my career I have often wondered what added satisfaction I might get from feeling soft glass on my hands, and the impulse to press, pull, or shape the taffy-like hot glass has scared me when the urge was the strongest.

Like Walt Whitman, I too sense the mysteries of the artist's hands, their mechanized and synchronized responses to the heart

and mind, all working in unison to celebrate our humanness. And so my hands and tools, the animate and inanimate, exemplify a sweet rhythm which becomes the conduit that has allowed me to express myself while creating beauty.

In my craft, I use relatively few hand tools — tweezers, a carbon paddle, and a glass cutting knife — and a few others that date from the sixties, those that I have worked with since my student days, that are very sentimental to me. My prayer is to look back at the end of my career and feel that I have given it my best. That one day I will place my hand tools alongside my grandfather's in the beautiful, old wooden box and that my children and my grandchildren will cherish their heritage, one of artistic integrity and the pursuit of excellence.

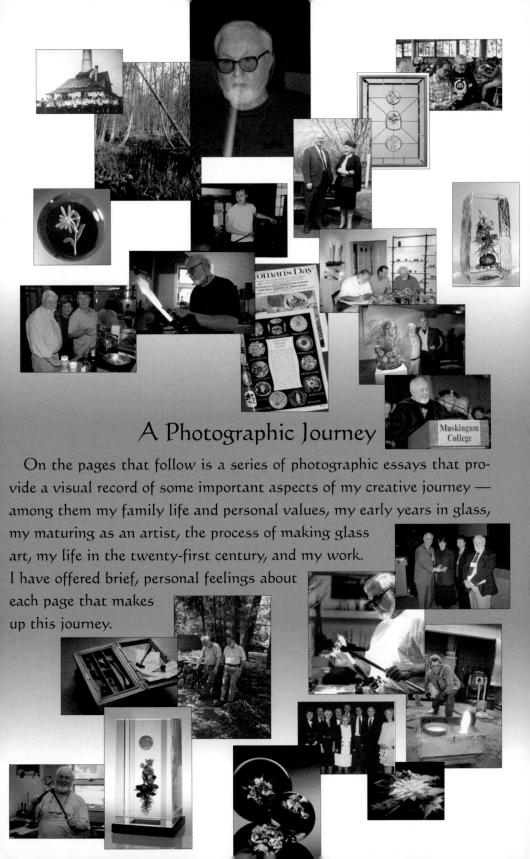

A Photographic Journey

On the pages that follow is a series of photographic essays that provide a visual record of some important aspects of my creative journey — among them my family life and personal values, my early years in glass, my maturing as an artist, the process of making glass art, my life in the twenty-first century, and my work. I have offered brief, personal feelings about each page that makes up this journey.

PLATE II

PROLOGUE

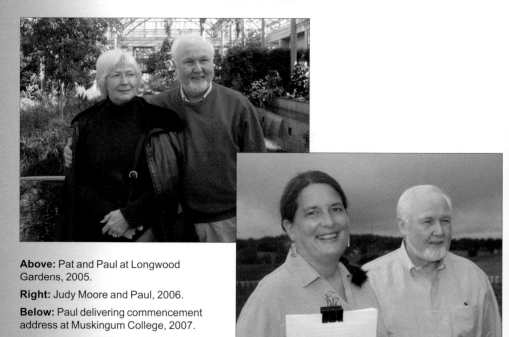

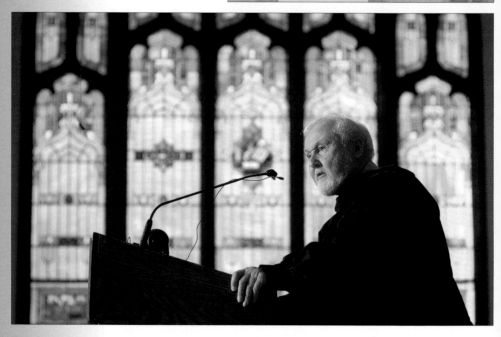

Above: Pat and Paul at Longwood Gardens, 2005.

Right: Judy Moore and Paul, 2006.

Below: Paul delivering commencement address at Muskingum College, 2007.

I would never have achieved the success that I now enjoy had it not been for the enduring support of my wife Pat, and I would never have completed this book had it not been for the editorial support and informed advice of my friend Judy Moore. The commencement address that I delivered at Muskingum College allowed me to share strongly felt beliefs on education with the graduating students.

PLATE III

FROM THE FAMILY PHOTO ALBUM I

Top left: Mary Florence McGivney, Paul's mother, while in her teens.

Top right: Martin Francis Stankard, Paul's father, 1940.

Above: Brothers Martin (right) and Paul, 1946.

Left: Infant Paul and his mother, 1943.

My parents were both Irish Americans, and my early years were spent in an Irish Catholic neighborhood of North Attleboro, Massachusetts. My family had gardens and nature was always nearby, so I was constantly in the company of greenspace and beautiful flowers.

PLATE IV

FROM THE FAMILY PHOTO ALBUM II

Left: The Stankard children, Christmas holidays, 1956. Paul is seated on the couch, second from the left.

Below: Paul, facing camera, as a paperboy, 1956.

Bottom: The Stankard children and their mother, 1960. Paul is standing in back, behind his mother.

Growing up in 1950s working-class America, the importance of family closeness, a strong work ethic, getting an education, and doing a job well were all instilled in us children. I learned much from my paperboy experience — during which time I sometimes paid my brothers to help me. While I was still a child, we lost one of our sisters — and thereby learned about the sometimes harsh realities of life.

PLATE V

FROM THE FAMILY PHOTO ALBUM III

Above: Salem County Vocational Technical Institute Scientific Glassblowing Technology Class, 1963. Paul is in the second row, kneeling, at left.

Left: Paul at Boston Commons, near the bus terminal, enroute to Nashua, NH, 1963.

Below: Pat during a family vacation in Maine, 1976. The bouquet of field flowers she is holding later inspired the paperweight shown below.

My artistic curiosity started to emerge even before I left Salem Institute — where I was dubiously nicknamed "The Ornamental Glass King" because, every chance I had, I would lampwork a piece of ornamental glass. Such activities were not encouraged in Salem's technical environment — or in any other industrial setting in which I found myself for most of the next decade.

PLATE VI

FROM THE FAMILY PHOTO ALBUM IV

Left: Stankard family portrait, 1975.

Below: The Stankard family at Longwood Gardens, 1986.

Above: Opening night of "Paul Stankard, A Floating World: Forty Years of an American Master in Glass" exhibit, Museum of Arts & Design, New York, May, 2004. Pictured are members of the Stankard family, David and Sandra Graeber, and Flo Diorio.

Right: Grandchildren push grandpa into the home pool, 2006.

Both my family and my art are important to me. Throughout my adult life, I have been committed to the need to support my family while I pursued my calling as an artist. Success at either is not easy, but I have given my best to achieve both.

PLATE VII

THE EARLY YEARS IN GLASS I

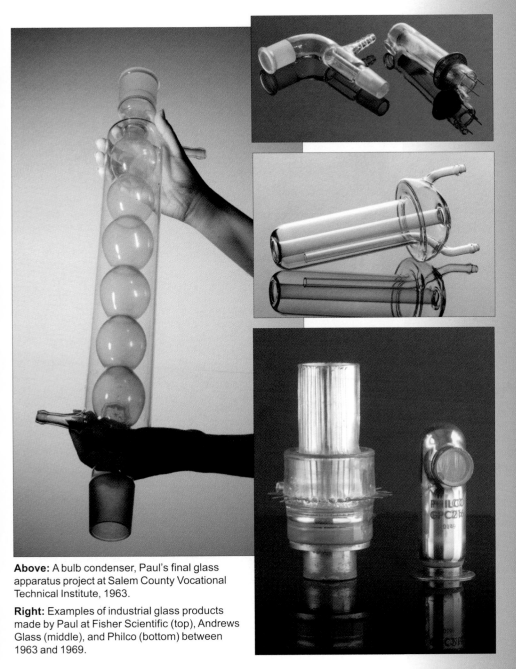

Above: A bulb condenser, Paul's final glass apparatus project at Salem County Vocational Technical Institute, 1963.

Right: Examples of industrial glass products made by Paul at Fisher Scientific (top), Andrews Glass (middle), and Philco (bottom) between 1963 and 1969.

My years of working in industrial glass, my enthusiasm, and my commitment to doing a job as well as I possibly could allowed me to master a wide range of lampworking techniques that eventually found their way into my glass art.

PLATE VIII

THE EARLY YEARS IN GLASS II

Above: Penny in bottle, 1965.

Above right: The crucifix made for Father Kernan, 1965.

Right: Destruction of rejected paperweights, 1972.

Below: Promotional piece distributed by Reese Palley, 1972.

PAUL JOSEPH STANKARD
Master Paperweight Maker

The period from 1965 to 1972 was a time of transition for me. I stopped making ornamental gifts and started focusing on floral paperweights. To my great pleasure, and especially with the assistance of Reese Palley, people were eager to buy my paperweights.

PLATE IX

THE EARLY YEARS IN GLASS III

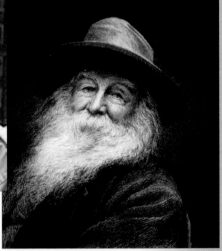

Above: Reese Palley, 2004.

Right: Walt Whitman.

Below: Mike Diorio and Paul photographing water lilies, 1999.

Three very special people have become a part of my creative life and have influenced the direction, content, and success of my artistic efforts. Reese Palley entered my life in 1972, and I met Mike Diorio around 1975. I made the acquaintance of Walt Whitman around 1983, and his vision of the "ordinary as extraordinary" profoundly influenced how I approached art-making thereafter.

PLATE X

WHEATON I

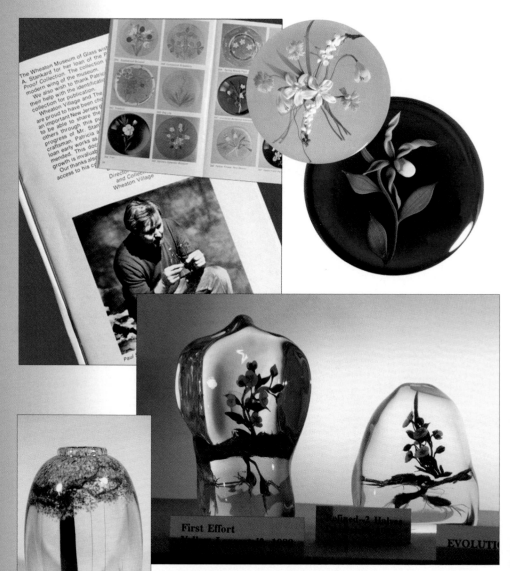

Top: "First Decade Exhibition" catalog, Museum of American Glass, Wheaton Village, 1979, and two paperweights from the 1970s.

Above: Experimental efforts to expand glassworking techniques beyond paperweights on exhibit at Museum of American Glass, 1980.

Left: "Swing at Horton Hall," lampworked colored glass on blown-glass base, Mark Peiser, 1979.

Through the 1970s, as my success with paperweight making continued and allowed me to progressively refine and improve my techniques, I began to investigate and explore new ways to express my feelings. The possibility of presenting my floral designs vertically appealed to me, and I was deeply inspired by Mark Peiser's work that combined blown and lampworked glass.

PLATE XI

WHEATON II

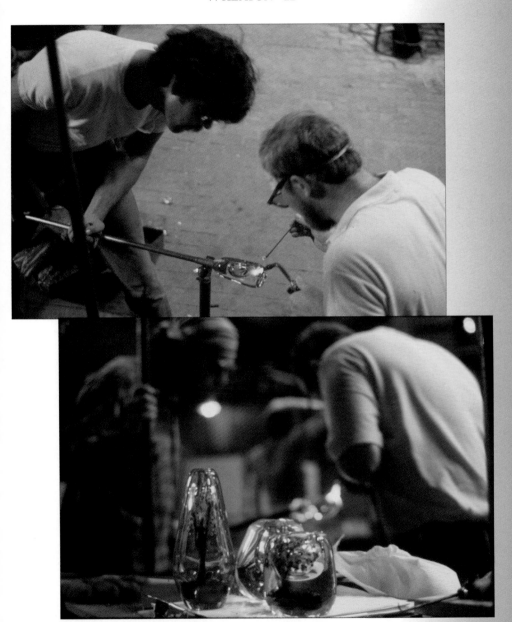

Lampworking colored-glass details onto blown glass, Wheaton Village factory floor, 1980. Paul, as artist-in-residence at Wheaton Village, is working with master glass artist Don Friel (top, on left) and applying lampworked details onto blown-glass bases.

In 1980, as artist-in-residence at Wheaton Village and inspired by Mark Peiser's work, I had the opportunity to experiment with furnaceworking techniques and gain confidence in the use of new glassworking skills. I wanted to grow beyond being a paperweight maker into a realm where I could express my art in original forms.

PLATE XII

PENLAND I

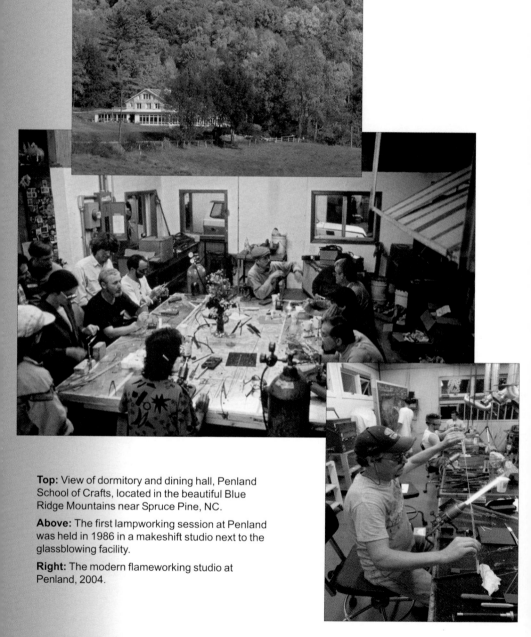

Top: View of dormitory and dining hall, Penland School of Crafts, located in the beautiful Blue Ridge Mountains near Spruce Pine, NC.

Above: The first lampworking session at Penland was held in 1986 in a makeshift studio next to the glassblowing facility.

Right: The modern flameworking studio at Penland, 2004.

I found Penland in the mid-1980s to be an exciting place where the traditions of craft and art came together in an uninhibited environment of interaction and creativity. Most glass artists who I met were furnaceworkers, so we both had plenty of new techniques, experiences, and questions to offer the other.

PLATE XIII

PENLAND II

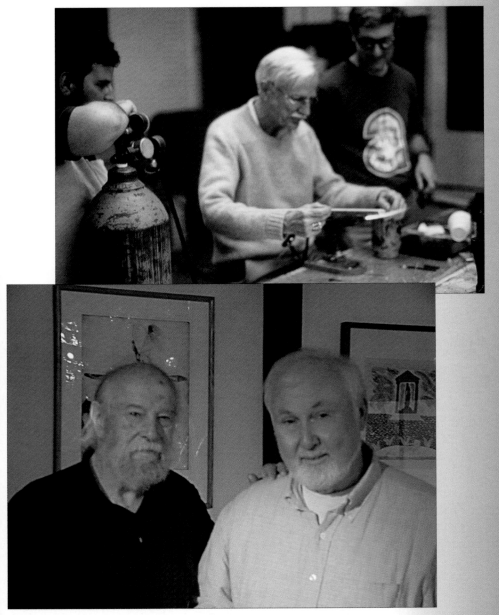

Top: Paul Hollister, Jr., guest lecturer, in the Penland lampworking studio, 1986.
Bottom: Harvey Littleton and Paul in Harvey's studio, Spruce Pine, NC, 2005.

Paul Hollister, Jr. and Harvey Littleton are two people who inspired me greatly as I evolved from making paperweights in the early 1970s toward more artistic expression in my work. Hollister gave me criticism and advice for continuing growth, and Littleton created the intellectual and aesthetic environment within which the studio glass movement — to which I was attracted — became established and flourished.

PLATE XIV

SALEM COMMUNITY COLLEGE I

Top: Salem Community College campus, Carneys Point, NJ, 2006.

Middle: The glass facility at SCC used for both scientific glass and glass art.

Bottom: Henry Halem (left), Paul, and students in the Paul Joseph Stankard Gallery at SCC, 2001. Henry is critiquing art on display in the gallery during a visit to SCC as a guest lecturer.

I find it a joy to be associated with Salem Community College after having graduated from the institution forty-five years ago. My involvement with the school in recent years has been diverse and rewarding, ranging — as it has — from advising on the glass-art program to helping create the International Flameworking Conference to teaching.

PLATE XV

SALEM COMMUNITY COLLEGE II

Demonstrating flameworking tech-
niques, International Flameworking
Conference, SCC, by Cesare Toffolo
(top) in 2004 and Robert Mickelsen
(above) in 2001.

Right: Ginny Ruffner and Paul,
International Flameworking Confer-
ence, SCC, 2006. Ginny was
presented with the International
Flameworking Conference Award of
Excellence at this meeting.

The International Flameworking Conference, held annually at Salem Commu-
nity College, brings world-class artists involved with flameworking to the cam-
pus. Each year the Conference recognizes, and bestows an Award of Excellence
upon, an outstanding flameworking artist. Robert Mickelsen, Ginny Ruffner, and
Cesare Toffolo are three recipients of this high recognition.

PLATE XVI

MAKING GLASS ART I

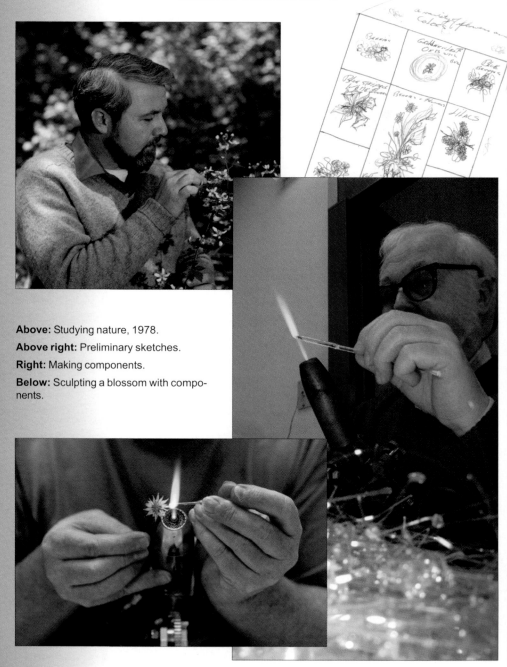

Above: Studying nature, 1978.
Above right: Preliminary sketches.
Right: Making components.
Below: Sculpting a blossom with components.

I have been obsessed for more than forty years with the challenge of, and need for, translating nature into glass, and I have educated myself to be successful at achieving this goal. My creative vision has been dominated especially by the mysteries of the plant kingdom, the mystical spiritualism of Thoreau and Whitman, and the need to incorporate more depth and symbolism into the expressions I create.

PLATE XVII

MAKING GLASS ART II

Right: Letter rods to be bundled into a signature cane.

Below: Sealing floral components with a hand torch.

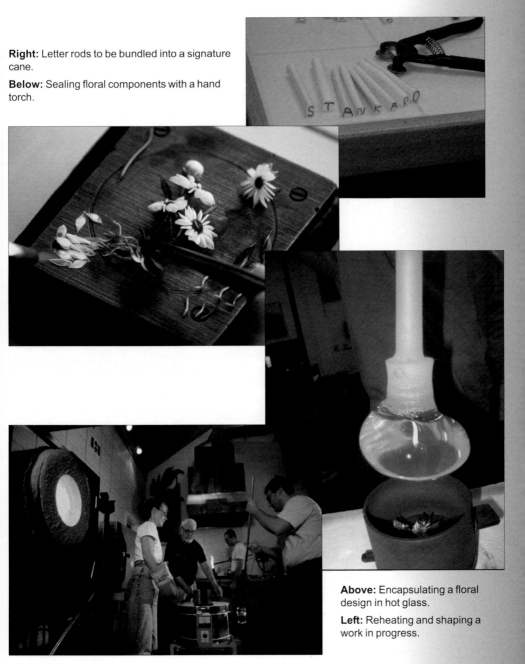

Above: Encapsulating a floral design in hot glass.

Left: Reheating and shaping a work in progress.

The encapsulation of lampworked components into glass merges scientific training and artistic expression. It is a labor-intensive process that requires considerable technical skill and is fraught with high risk.

PLATE XVIII

MAKING GLASS ART III

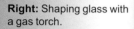

Right: Shaping glass with a gas torch.

Below: Reheating in the glory hole.

Above: Coldworking an orb by grinding it into a sphere, then polishing it.

Left: Finished artwork displayed for sale in the Marx◆Saunders booth during SOFA Chicago, 2006.

Finishing a piece of art makes it ready for the next step of being displayed, for sale or appreciation, in such venues as galleries and museums. Among the most valued of recent advances in my art-making has been my ability to create spherical forms, or orbs, and for this opportunity I express deep gratitude to my friend Bob Stephan who proposed the possibility to me and who now finishes my orbs.

PLATE XIX

AS A NEW CENTURY BEGINS I

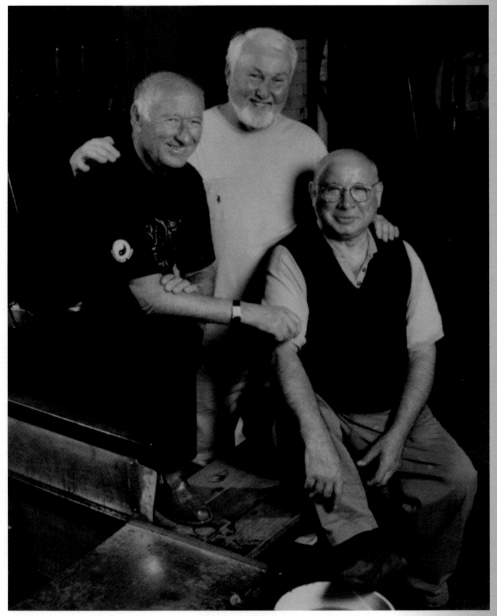

Jiri Harcuba (left), Paul Stankard (center), and Lino Tagliapietra (right) while teaching at the Studio of the Corning Museum of Glass, 2002.

The Three Maestros — three men who have dedicated their lives to glass art and who have, in the process, become the masters of their crafts: Jiri Harcuba of engraving, Paul Stankard of flameworking, and Lino Tagliapietra of glassblowing.

Plate XX

As a New Century Begins II

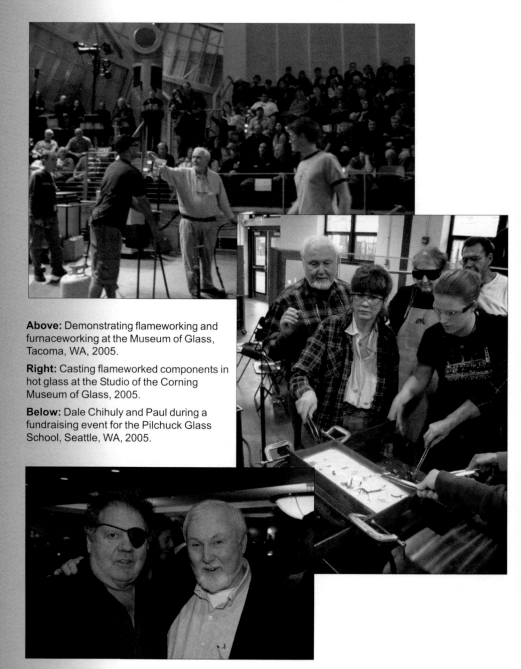

Above: Demonstrating flameworking and furnaceworking at the Museum of Glass, Tacoma, WA, 2005.

Right: Casting flameworked components in hot glass at the Studio of the Corning Museum of Glass, 2005.

Below: Dale Chihuly and Paul during a fundraising event for the Pilchuck Glass School, Seattle, WA, 2005.

Teaching and sharing have become increasingly important to me with the passage of time. As we enter this new century, I find myself involved in more diverse activities than ever before, and many of these efforts involve mentoring and inspiring students and young artists.

PLATE XXI

As a New Century Begins III

Top: The lecture "Glass Flowers and Walt Whitman" being delivered at the Renwick Gallery, Smithsonian Institution, Washington, DC, April, 2006.

Middle: Students in the Urban Glass bead project, Brooklyn, NY, visiting Stankard Studio, 2006.

Right: Opening of the joint Katherine Stankard Campbell and Paul Stankard exhibit at Wheaton Village, Millville, NJ, 2000. Pictured here, left to right, are Katherine, Joseph, Paul, and Christine.

Having participated in the oral history program of the Archives of American Art and having my work in the permanent collection of the US National Museum of American Art framed my presentation in the Renwick Gallery. Closer to home, I also have welcomed groups of students to Stankard Studio, and I enjoy promoting and facilitating the artistic growth of the Stankard Studio team.

PLATE XXII

AS A NEW CENTURY BEGINS IV

Right: Side view of Stankard Studio.

Below: The flameworking area of Stankard Studio, with Dave Graeber in the foreground and, in back, left to right, Katherine, Paul, Pauline, and Christine.

Above right: Inventory of colored glass rods.

Right: David and Christine flameworking components.

Stankard Studio contains facilities for a variety of glassworking processes and provides the space and opportunity for all members of the staff to be independently creative.

PLATE **XXIII**

As a New Century Begins V

Top: The Stankard home.

Above: Part of the family art collection displayed in the dining area.

Above right: Most books on the library shelves have been read with audio-aid.

Right: Entertaining artist Jon Kuhn, a longtime friend, and Bonnie Marx.

The Stankard home was built in 1969, then thoroughly renovated in 2002, a symbolic statement of our committment to the South Jersey area. Pat and I view our art as a part of our living environment and we wanted our collection to be a part of the ambiance that we created in the home when it was renovated.

PLATE XXIV

GLASS I

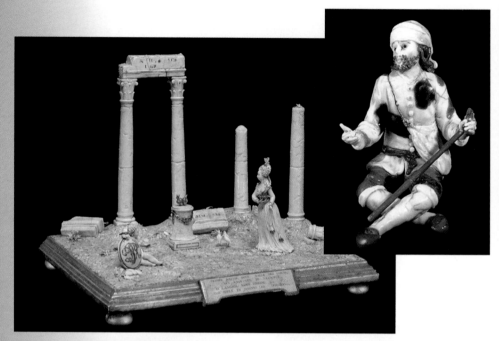

Above: Two examples of historic French flameworked glass from the Corning Museum of Glass collection.

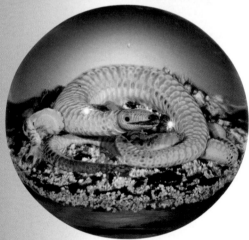

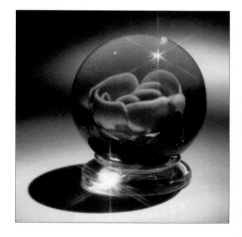

Above: A historic French paperweight from the mid-nineteenth century.

Right: A Millville Rose paperweight from the early twentieth century.

Historic glasswork was a significant part of the foundation upon which I built my career. The French lampworked pieces showed the detail that could be produced, and the legendary Millville Rose was an important part of the South Jersey glass tradition around which I had grown up. These and similar resources challenged and inspired me as my commitment to make paperweights strengthened.

PLATE XXV

GLASS II

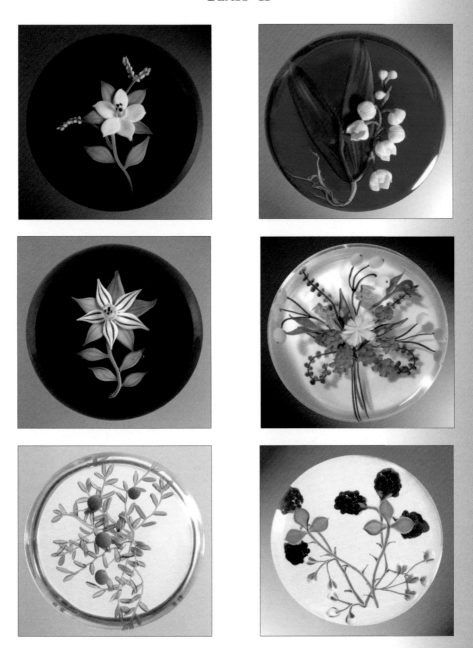

Paul Stankard paperweights from the 1970s and early 1980s.

I created the floral motifs of my paperweights during the 1970s and early 1980s as if they were botanical portraits. The challenges that I dealt with during this time were those of achieving high levels of detail and, subsequently, high levels of delicacy.

PLATE XXVI

GLASS III

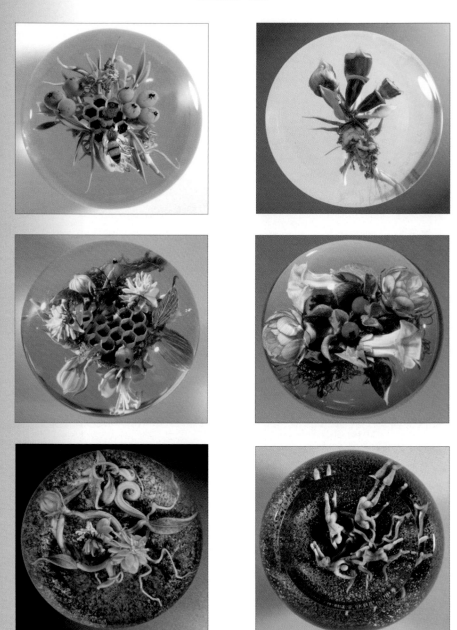

Paul Stankard paperweights from and after the 1990s.

My later paperweights evolved in complexity — both materially and spiritually — as I added depth of feeling to my work while integrating considerations of myth and the life cycle of nature.

PLATE XXVII

GLASS IV

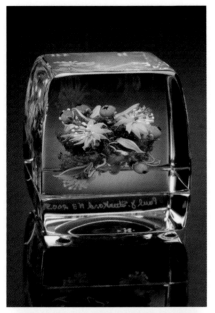

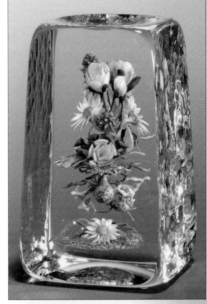

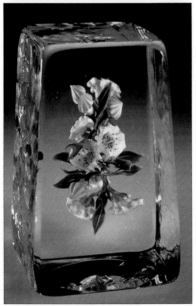

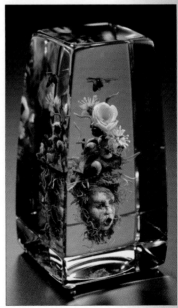

A cube (top left) and three botanicals created since the mid-1990s.

By presenting my floral subjects in the upright position, in a form I have called "botanicals," I was able to make them visible in three dimensions. This ability, in turn, allowed me to be more ambitious with my creative efforts.

PLATE XXVIII

GLASS V

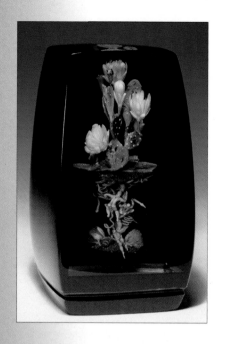
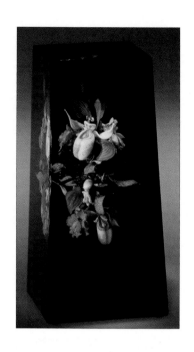

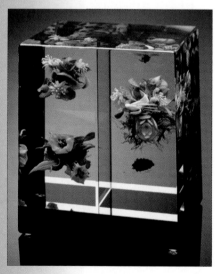
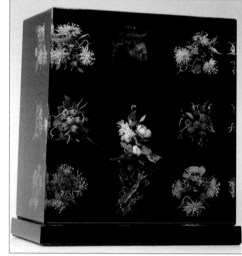

Two cloistered botanicals (top), a diptych (bottom left), and a cloistered assemblage (bottom right).

By adding complexity to the basic botanical unit, I was able to evolve the form into a larger size.

PLATE XXIX

GLASS VI

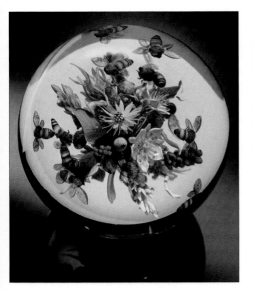 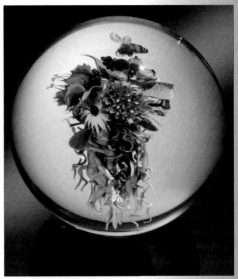

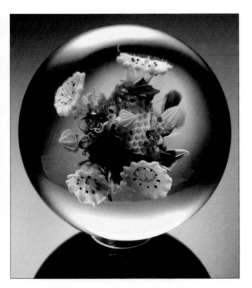 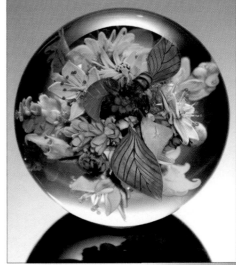

A selection of orbs from and after 2004.

Orbs allowed me to present my creative vocabulary in a new format — to express a new artistic vision based on the 360-degree view and magnification that the form provided.

PLATE XXX

GLASS VII

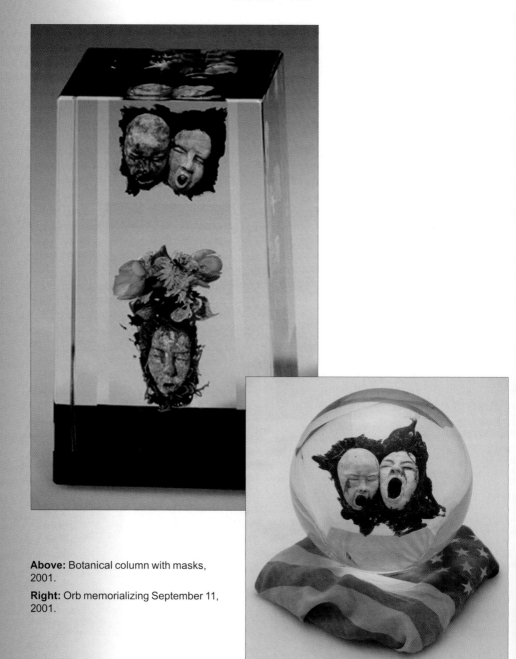

Above: Botanical column with masks, 2001.

Right: Orb memorializing September 11, 2001.

In 2001, my art became a vehicle for expressing the anger and anguish I felt over the death of my dear friend Mike Diorio and, later in the year, the events of 9/11.

PLATE XXXI

GLASS VIII

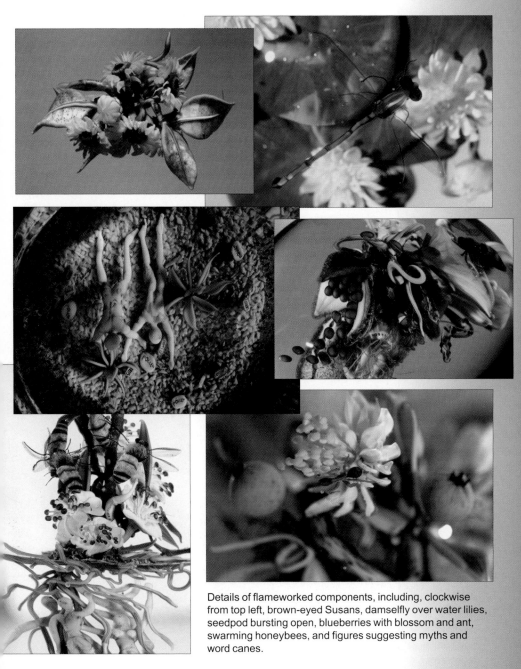

Details of flameworked components, including, clockwise from top left, brown-eyed Susans, damselfly over water lilies, seedpod bursting open, blueberries with blossom and ant, swarming honeybees, and figures suggesting myths and word canes.

Over the thirty-five years that I have been making glass art, my motifs have evidenced a growth and maturity at an intimate level. Today, my art invites the viewer into a visual dialogue with the intricate details of the workmanship and the mystical meaning of the theme.

GLASS IX

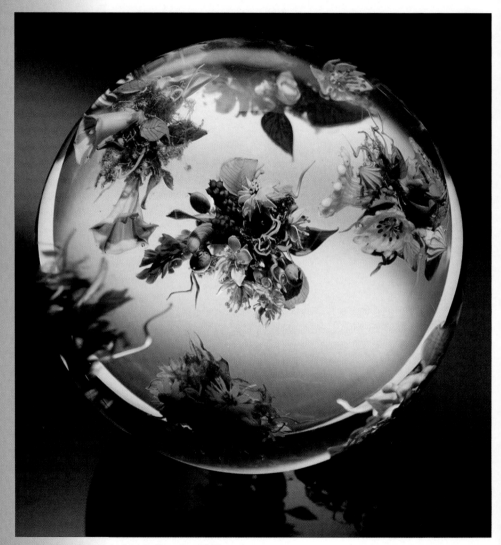

"Floating Bouquet" orb, 8-inch diameter, 2006.

The "Floating Bouquet" orb, with its seven floral components, presents an optical blending of colors and changing magnifications which suggest a floating metaphysical plant kingdom. The series that this piece represents is among the most ambitious undertakings of my career.

Index

Index

Index